WITH PEN & INK

EXPANDED EDITION

JAMES·HALL

FOREWORD FOR
THE MODERN READER
BY JEFF A. MENGES

DOVER PUBLICATIONS, INC.
MINEOLA, NEW YORK

Copyright

Copyright © 2020 by Dover Publications, Inc.
Foreword Copyright © 2020 by Jeff A. Menges
All rights reserved.

Bibliographical Note

This Dover edition, first published in 2020, is an unabridged republication of the work originally published by The Prang Company, New York, in 1913. The present edition has been expanded with a gallery of additional illustrations selected by Jeff A. Menges, who has also written a Foreword for the modern reader.

Library of Congress Cataloging-in-Publication Data

Names: Hall, James, 1869–1917, author. | Menges, Jeff A., editor.
Title: With pen & ink / James Hall; foreword for the modern reader by Jeff A. Menges.
Other titles: With pen and ink
Description: Expanded edition. | Mineola, New York: Dover Publications, Inc., 2020. |
 Includes bibliographical references.
Identifiers: LCCN 2019054444 | ISBN 9780486841922 (paperback)
Subjects: LCSH: Pen drawing—Technique.
Classification: LCC NC905 .H18 2020 | DDC 741.2/6—dc23
LC record available at https://lccn.loc.gov/2019054444

Manufactured in the United States by LSC Communications
84192801
www.doverpublications.com

2 4 6 8 10 9 7 5 3 1

2020

CONTENTS

Foreword for the Modern Reader by Jeff A. Menges ix

Preface by James Hall . xii

Introduction, including Materials, by James Hall xiii

DECORATIVE PEN DRAWINGS

First Problem
 To draw in pure outline a typical leaf or other nature subject 3

Second Problem
 To utilize pure outline in decorative arrangements applied to initials,
 head and foot pieces, and book plates 7

Third Problem
 To draw plant forms in outline and solid black 9

Fourth Problem
 To apply outline and black to decorative arrangements of the types
 considered in the second problem 13

Fifth Problem
 To apply outline and black to a simple architectural subject 15

Sixth Problem
 To apply outline and black to a figure subject with accessories 18

Seventh Problem
 To make a cover design in outline and black, using a decorative floral panel
 with the necessary lettering . 21

EIGHTH PROBLEM
 To make a cover design in outline and black by surrounding the panel containing
 the necessary lettering with a border varying in width to correspond with the
 margins of the type page . 23

NINTH PROBLEM
 To draw flowers in outline, black, and middle value 27

TENTH PROBLEM
 To render still life or still life with plant forms in several values 29

ELEVENTH PROBLEM
 To render typical landscape subjects in several values 33

TWELFTH PROBLEM
 To render a figure subject in several values 35

PICTORIAL PEN DRAWINGS

GENERAL STATEMENT . 40

THIRTEENTH PROBLEM
 To render simple still life forms in light and shade. 41

FOURTEENTH PROBLEM
 To render still life in a free manner . 46

FIFTEENTH PROBLEM
 To render plant life pictorially . 47

SIXTEENTH PROBLEM
 Simple outdoor subjects . 51

SEVENTEENTH PROBLEM
 The rendering of trees in winter and in summer 53

EIGHTEENTH PROBLEM
 The drawing of buildings . 57

NINETEENTH PROBLEM
 The sketching of figures . 61

TWENTIETH PROBLEM
 Studies of heads . 63

TWENTY-FIRST PROBLEM
 Complete figure sketches . 66

A Short List of Books . 69

LIST OF ILLUSTRATIONS
DECORATIVE PEN DRAWINGS

PLATE PAGE
1. Outlines of plant form . 5

2. Initials, book plates, and panels in outline 6

3. Plant drawings in outline and black . 11

4. Initials, book plates, and still life compositions in outline and black 12

5. Six renderings of an old house in outline and black 17

6. Four renderings of a figure composition in outline and black 19

7. Cover design embodying a floral panel in outline and black 20

8. Cover design embodying a floral border in outline and black 25

9. Flowers rendered in outline, black, and gray 26

10. Still life and plant form rendered in several values 31

11. Landscapes rendered in several values . 32

12. Figure compositions rendered in several values 37

PICTORIAL PEN DRAWINGS

13. Still life . 43

14. Still life . 45

15. Various plant forms . 49

16. Outdoor subjects . 50

17. Trees . 55

18. Buildings . 59

19. A page of small figure sketches . 60

20. Typical heads . 65

21. A young woman . 67

22. An old lady . 68

NEW GALLERY OF ILLUSTRATIONS
(following page 70, see additional source material on pages 69-70)

PLATE PAGE

23. "Summer Morning," F. H. Ball,
from *Pen, Pencil, and Chalk* . 71

24. "The Pirate," Monro Orr,
from *Pen, Pencil, and Chalk* . 72

25. "Love, Youth, and Death," A. Garth Jones,
from *Modern Pen Drawings* . 73

26. "The Vision of St. Agatha," Harold Nelson,
from *Modern Pen Drawings* . 74

27. "Grass Cutting," Lucy Kemp-Welch,
from *Modern Pen Drawings* . 75

PLATE PAGE

28. "Rustum and the Simoorg," Patten Wilson,
 from *Modern Pen Drawings* . 76

29. "Are not you he . . . ," Arthur Rackham,
 from *A Midsummer-Night's Dream* 77

30. "Portrait of Moffat P. Lindner," Fred Pegram,
 from *Pen Drawing and Pen Draughtsmen* 78

31. Illustration for Quevedo's *Pablo de Ségovie*, Daniel Vierge,
 from *Pen Drawing and Pen Draughtsmen* 79

32. "The Modest Rose Puts Forth a Thorn," Louis Fairfax-Muckley,
 from *Pen Drawing and Pen Draughtsmen* 80

FOREWORD FOR THE
MODERN READER

LINES drawn in ink produce bold statements on paper—they are definitive—their placement on the surface is either black or white. Constructing visual representations from these marks can be refined to a skill, and for some, even be made into an occupation. When James Hall wrote *With Pen and Ink* in 1913, he had already been teaching Art in New England and New York, and saw ink work as a practical art form to be instructed in schools. Newspapers and magazines were booming—as were books—and the primary method to create illustrations for their use was by drawing with ink.

The same clear distinction that makes ink so challenging to train into representative images makes it ideal for simple methods of reproduction, like those used in early industrial printing. Artists such as Charles Dana Gibson, James Montgomery Flagg, and Edwin Austin Abbey practically became household names, due to their skill and sensitivity with the black line.

Style, image, and message can all come through a single line, making pen and ink work as communicative today as it has been for centuries. It is different from other rendering methods due to the straightforward contrasting options of light or dark. There is little opportunity to build when the slightest commitment goes immediately to a full black—the vision happens when the artist makes *interpretive* marks, deciding what is black or white. The appearance of halftones needs to be manufactured, but with practice can be done convincingly.

✦ ✦ ✦

The lessons in *With Pen and Ink* can take the reader from basic decorations to full figure rendering from life. While the guidance and methods are wholly applicable, the tools have transformed considerably since the book was written in 1913. This needs a bit of attention for the modern user.

In his original Introduction, James Hall addresses the materials needed for pen and ink work. The board he mentions—Bristol board—is still one of the better options for a drawing surface concerning ink. It is readily available in pads or sheets. Of the pens he refers to, the Gillott 303 and 404 nibs are also still available. Both can be found separately, and in the Gillott Drawing Set. The Esterbrook Bank Pen No. 14, however, is a thing of the past. They can still be found online, but at more premium prices. It can be substituted for today by another medium-line nib. Others found in the same Gillott Drawing Set will do fine.

Originally, work within this book was done with a pen dipped into an inkwell or bottle, or with a brush. "Dip pens" can still be purchased today, and they offer the user a more organic line—one subject to irregularities and variance, which is part of its charm. A dip pen is usually two parts: a metal "nib," the shape of which can determine the ink flow and the line width, and the corresponding handle, in a variety of shapes and materials. Choice of the handle is largely a personal preference, though some handles are shaped better for specific tasks such as calligraphy. With practice and familiarity, the best aspects of this can be put to good use and deliver warm, personable drawings. Speedball is the largest American producer of dip pens; Kuretake nibs are a sought-after brand from Japan; as is Gillott from England. An internet search or a trip to a better art supply store will still yield options for anyone who wishes to experience the practice as it has been done since long before the book was originally written.

There are many other pen options available to an inker today. Other than the dip pen, cartridge based fountain pens offer similar flexibility in line control with a fluid ink, without the need for a well. While in the past they have been expensive and collectable, interest from artists has encouraged manufacturers to develop some affordable, quality options. Rotring manufactures an "Art Pen" with all the properties of the fountain pen at a very reasonable price, and the Lamy Safari is a reliable option, popular with beginners and professionals for good reason.

The "brush-pen" has been born from Japanese calligraphy needs and has a greater range of stroke width and flexibility. This is a soft-tipped pen with a long, flexible point that allows for brush-like strokes as well as fine detailing. These are now available worldwide, and in pocket-friendly varieties. While popular among calligraphers, they can be very expressive and convenient for

pictorial artists as well, offering the convenience of a capped pen that has the mark-making depth of a brush.

Technical pens have been a part of the artist's toolbox since the mid-twentieth century. Originally used by architects and draftsmen, technical pens do not waver in the size of their line, producing a more precise, measured appearance. It is not unusual to work with multiple technical pens to produce a range of line quality, with each producing its own consistent mark. These are also available in refillable—like a fountain pen, or from a number of different manufacturers as disposables. The Sakura Pigma Micron Pens are easy to find in a wide array of sizes. Also available with sepia ink, these offer a warm alternative to the standard black.

Even the most commonplace drawing pens can be welcome in the artist's hand: ballpoint pens, standard felt-tipped markers, even heavy permanent markers. All have their place for mark-making and expression, and someone out there is making beautiful pictures using them. For results that would be best suited to these lessons, the dip pen or fountain pen will be the option that will most closely follow Hall's direction. Every pen user needs to find the balance of convenience and line quality to choose the right instrument. While it is easy to settle with a favorite, experimentation is encouraged—knowing the properties of multiple drawing tools will help you pick the right one for each piece.

Jeff A. Menges

PREFACE

SOME years ago the author brought out a little book called "With Brush and Pen," being "suggestions for some of the newer phases of public school art instruction." It seemed to meet a need at the time of its appearance and received more commendation than had been expected. The book has been for years out of print, but requests for it led to the consideration of bringing out a revised edition. It was then decided that a revision of the earlier production was out of the question. Excellent advice upon all phases of elementary work is now available, and the need for such a book as "With Brush and Pen" no longer exists as it did when the book was written.

There seemed, however, a place for a treatise upon pen drawing which should discuss the subject with sufficient definiteness and simplicity to be of use to high school teachers of drawing as well as to art students. Therefore the portion of the old volume dealing with pen drawing has been rewritten. A very little of the original matter has been kept, two or three of the illustrations and the semblance of the old name.

INTRODUCTION

THE aim of this book is to present a series of definite exercises which are progressive in sequence and as a whole comprehend typical problems in the two kinds of pen drawing which are here termed decorative and pictorial. The decorative pen drawing is taken up first because it is by far the simpler and more definite, and the practice which is here given lays a good foundation for the freer representative work which follows. The two sections of the book may, however, be studied independently of each other. In fact to a certain extent each problem is a complete exercise, and it is not expected that many students will work out all the problems in the order in which they are given. Such a plan it is believed would be well worth while where time permits, but it will be evident to anyone who looks through the following pages that they allow of selection. For example, still life and flowers may be all that can be attempted in a short pen and ink course. In such a case it would be easy to omit all else. In any selected course, however, the first, third, and ninth problems should be studied.

The book does not aim to treat of drawing or of composition except as it is inevitable in a discussion of the handling of pen and ink. No treatise upon a special medium, however, is possible that does not constantly consider the universal principles of art, and so there are occasional apparent digressions from the particular subject. To some it may seem that the book should deal more fully with the questions of drawing, lettering, and composition — which are referred to in the text. For such, a short list of books upon drawing, composition, and design is given which may be referred to in case of need.

The value of learning to draw with the pen is twofold. First, there is the educational value of the medium. None, unless it be the etcher's needle, is so purely a linear tool. Pencil, crayon, and charcoal partake of the character of the brush. They allow of laying in a value light or dark.

But the pen is a means of drawing lines only, and is uncompromisingly the tool for the sharp delineation of shapes. The grays must be obtained by drawing lines at different distances apart, but the lines are always in evidence. Therefore the study of pen drawing is essentially the study of *line*, and in learning to draw with the pen one learns, as in no other way, to appreciate precision of draughtsmanship and that beauty of line which is so important a factor in the graphic arts.

The practical value of pen drawing lies principally in the fact that it can be reproduced at a reasonable price by means of zinc etching or photo-engraving. It is therefore the best medium to use in connection with printing. A pen drawing, moreover, because it is linear, may be made to harmonize with type better than a drawing in any other medium.

The making of pen drawings for reproduction and use with type has come to be a common problem in schools where printing presses are found, and the use for such pen drawings is manifold. There are, therefore, good reasons why pen and ink should be made a part of a high school course. Its continued use in the field of commercial design and illustration in these days of photography indicates the appeal which linear art makes to the eye. The inherent charm of a pen and ink drawing insures its lasting place in the fields of fine and applied art.

MATERIALS

The materials for pen drawing are few and inexpensive.

The best surface is that of Bristol board of perfectly smooth texture. It should be of a quality which will permit of scratching out with a very sharp knife without causing the surface to become absorbent. The standard makers of Bristol board produce it in various weights. Three or four sheet thickness is heavy enough for very satisfactory results. A thinner board will serve the purpose for practice work, and in fact a smooth unruled writing paper presents a fair surface. The best results, however, require a fairly heavy material with a smooth hard surface which will remain perfectly flat.

Many pen draughtsmen rely upon three pens for all kinds of work: Gillott's 303 and 404 and Esterbrook's Bank Pen No. 14. The drawings in this book are all made with one of the first two and they are all that the student will require, so no mention need be made of other excellent finer and more elastic pens or of coarser ones for special work. The pro-

fessional may use them to advantage. The three pens named are all-sufficient for the production of excellent work. No finer pen than 303 is necessary, and the Bank Pen is large enough for making an evenly decorative fairly broad pen line.

Perfectly black liquid India Ink is the only kind for the student to use. It may be bought waterproof or otherwise. The waterproof variety is necessary if water color is to be used over the pen drawing. Otherwise the ordinary India Ink is perhaps preferable.

A hard pencil for preliminary sketching, a soft rubber for erasing pencil lines and cleaning the finished drawing, a drawing board, and thumb tacks complete the necessary equipment.

DECORATIVE PEN DRAWING

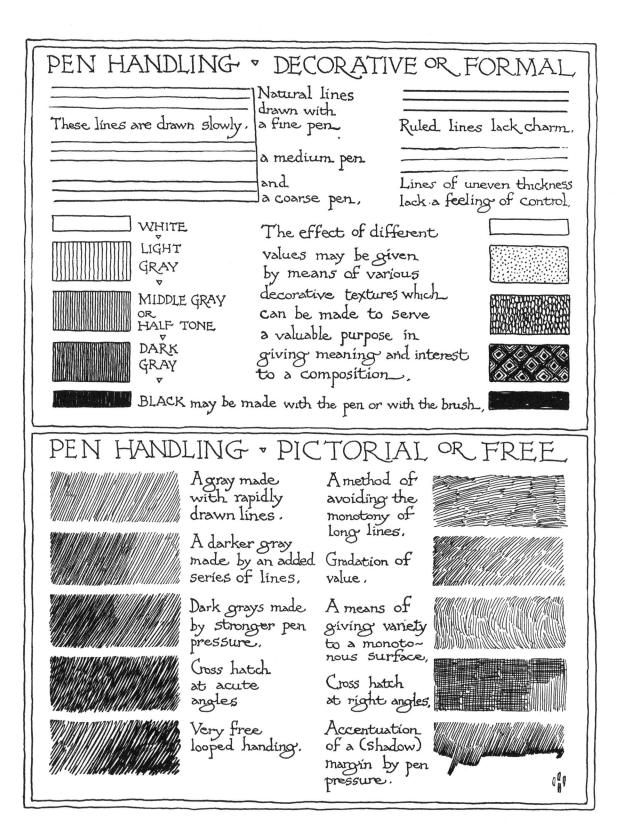

PEN HANDLING · DECORATIVE OR FORMAL

These lines are drawn slowly.

Natural lines drawn with a fine pen.

a medium pen

and a coarse pen.

Ruled lines lack charm.

Lines of uneven thickness lack a feeling of control.

WHITE
▽
LIGHT GRAY
▽
MIDDLE GRAY OR HALF TONE
▽
DARK GRAY
▽

The effect of different values may be given by means of various decorative textures which can be made to serve a valuable purpose in giving meaning and interest to a composition.

BLACK may be made with the pen or with the brush.

PEN HANDLING · PICTORIAL OR FREE

A gray made with rapidly drawn lines.

A darker gray made by an added series of lines.

Dark grays made by stronger pen pressure.

Cross hatch at acute angles

Very free looped handling.

A method of avoiding the monotony of long lines.

Gradation of value.

A means of giving variety to a monotonous surface.

Cross hatch at right angles.

Accentuation of a (shadow) margin by pen pressure.

DECORATIVE PEN DRAWING

FIRST PROBLEM

To draw in pure outline a typical leaf or other nature subject

THE first step in the making of a good pen outline is the making of a thoroughly good pencil outline. This pencil drawing may be made in light lines directly upon the Bristol board which is to contain the final ink drawing, or it may be made on separate paper and transferred to the Bristol board. Either plan of procedure has its own difficulties. If the drawing is made directly on the Bristol board a moderately hard pencil should be used with a very delicate touch, or cleanliness of workmanship cannot be maintained. If the drawing is made on separate paper any amount of erasure and correction may go on without regard to the appearance of the paper but great care must be taken lest in transferring the drawing its character be injured. If the pencil work is well done by either method a clean, light, firm outline upon the Bristol board will be the result.

With a Gillott's 404 pen, the inking may now begin. The width of the line should be that produced naturally when the minimum of pressure is used, and an even line throughout the drawing is to be held in mind as the ideal toward which to strive. The line should be drawn deliberately and always with thought for the form that is being expressed. If the pen line is merely a tracing over the pencil line, the final drawing will be weak and without meaning. While the pencil lines serve as a guide, the aim should be to correct and refine the forms in the inking.

One is liable to draw the pen line on or within the pencil line with the result that the spaces within the lines become contracted giving a shrunken and insignificant character to the drawing. Thus forewarned the student should carefully watch the inside of the pen lines as he proceeds remembering that the significance of the drawing lies in the shapes which the lines define, rather than in the lines themselves.

The pen should be held not very differently from the way it is held for writing. Perhaps more explicit directions would hinder more than they would help the student. He should experiment until he finds that he can draw lines freely and firmly using either a finger or a wrist movement according to the length of the line he is drawing.

As a general rule the pen should move over the paper in drawing a line so that the nibs travel beside each other, for if the line is formed by the edgewise movement of the nibs, it will generally be a finer and more scratchy line. It may prove good practice to begin by drawing the border lines. A freehand line is never absolutely straight like a ruled line and the student should learn to judge of the quality of a freehand line by the right standards.*

Much of the beauty of a pen and ink outline drawing lies in its precision. Great care must be taken where lines meet. A slight crossing or a space where there should be an exact meeting of lines will make slovenly an otherwise good drawing.

The drawings in plate 1 might profitably be copied for quality of line before original work is attempted.

It should be noted that the primary veins only are shown. There are several reasons for this which the student will appreciate as he proceeds, but it should be evident to anyone that a pleasing simplicity of effect is thus preserved.

<div align="center">* See plate page 2 (Pen handling).</div>

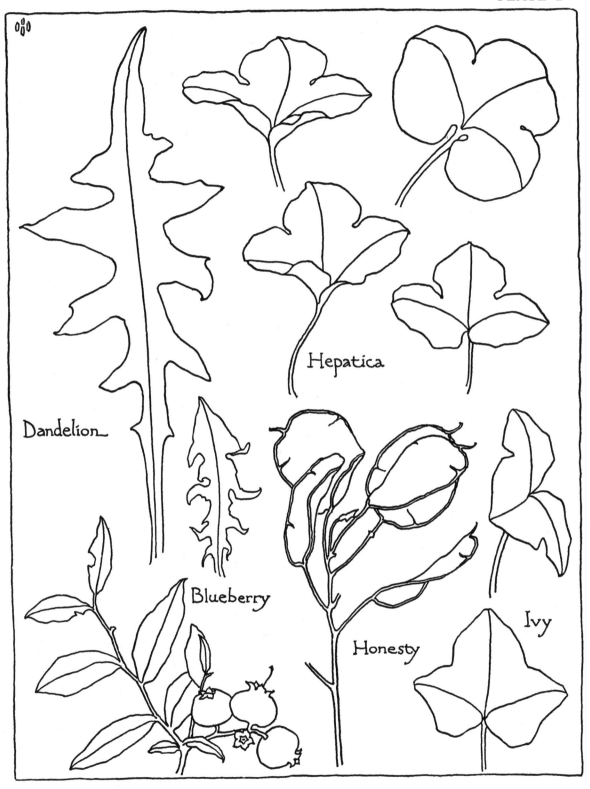

PLATE 1

Hepatica

Dandelion

Blueberry

Honesty

Ivy

PLATE 2

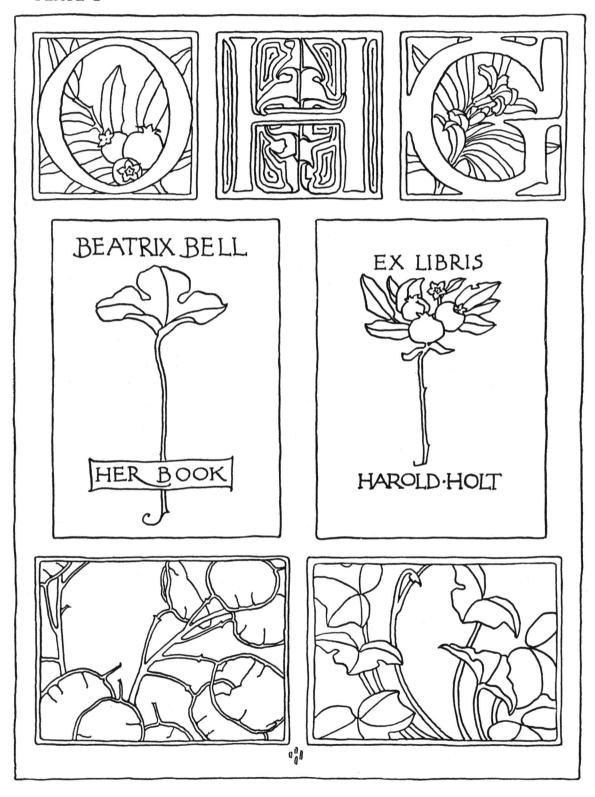

SECOND PROBLEM

*To utilize pure outline in decorative arrangements applied to initials,
head and foot pieces, and book plates*

THE illustrations in plate 2 are drawn with the same pen and with the same considerations in mind as were those in the previous plate, with the added aim of producing in each drawing a complete decoration. Therefore there has been in each case a careful consideration of the composition of lines and spaces within the enclosing form. In each of the three initials it should be noticed that a double square has first been drawn. In the first initial the outer circle of the O is slightly greater in diameter than the inner square, so that it breaks through the square at the centre of each of its sides. This gives to the letter a fuller, more dignified appearance than it would have if it were of exactly the diameter of the square, and moreover a confusion of the lines of the circle and square is avoided. When the inner elliptical line of the letter is drawn five background spaces are formed. The twig of blueberry is so disposed that it is well distributed and each of the five spaces is so cut that a pleasing variety of sizes and shapes is the result of the division.

The background of the initial H has been broken first by an outline of a dandelion, semi-formally placed. Then all the remaining spaces have been filled by freely drawn parallel lines. This treatment really produces the effect of a light gray surrounding the letter and leaf and forecasts another step in decorative pen work. A decorative conventional treatment of the larger veins of the leaf is another point to be noted in this drawing.

In the case of the letter G the distinctive method is the merging of the letter with the marginal space.

After copying one of these initials the student should proceed to compose other letters with any appropriate nature material, keeping to exactly the same kind of treatment that he has used in the copy. The judicious selection and composition of plant form with the various letters will give ample opportunity for the exercise of artistic judgment and originality.*

* For forms of letters study plain Roman capitals. See alphabets Brown, Strange, Day, Johnston. (Bibliography p. 69.)

The book plate designs are intended to show how very simple material can be used with free single line lettering so as to produce pleasant ensembles. The first book plate might well serve as a type for a number of experiments, any long stemmed leaf or flower being substituted for the hepatica leaf here used. The flourish at the base of the stem gives a finish and decorative character to the drawing which should not be overlooked. Otherwise the subjects are but slightly modified from natural forms, although in the blueberry drawing the arrangement of the leaves has been somewhat formalized to produce the triangular massing which the decoration possesses.

The two horizontal panels at the bottom of the page are typical of book decorations which are suitable for use with a medium sized type. An initial and a footpiece of the character of these shown in the plate could be used agreeably in the same piece of printing. The width of a pen line in a decoration to be used with a given kind of type depends entirely upon the "weight" of the type. If the lines of the type letters are heavy then a coarser pen should be used. If the type face is "light" a finer pen should be employed.

THIRD PROBLEM

To draw plant forms in outline and solid black

THESE drawings in method are like the outlines of plate 1 with certain parts filled in black to give a suggestion of color. The filling in is done with the pen by a series of strokes made with enough pressure to cause the ink to flow freely. Of course some care must be exercised to control the flow of ink and keep it within the areas to be filled. A brush may sometimes be used in place of the pen for filling in the blacks, but it may be seen that the pen strokes which still appear in the blacks of several of the drawings give added character. Study of the different drawings will reveal several methods of effectively translating the contrasts of nature into terms of outline and black.

In number 1 the black is used to give color to stems and leaves and also to the center of the flower. The midribs of the leaves, however, remain light. It should be noted that slight spaces are left where stems pass behind leaves, etc., in this drawing, as also in some of the others. This method of separating forms is employed much by the Japanese in their brush drawings and is a useful and effective device for avoiding confusion of parts. It is, however, a device that should not be overdone, as it may easily degenerate into a meaningless trick if resorted to when not necessary to give clarity of expression.

In number 2 the blacks serve as a means of distinguishing the upper from the under sides of the leaves. As it will be found that the upper sides of leaves are usually darker than their under sides, the method used in this drawing is of very general application in decorative pen work from plants. The careful drawing of the veins in the under sides of the leaves gives reality to those parts.

The radiating lines representing the gills in the mushroom drawing, besides delineating the structure, produce a decided gray. Hence drawing number 3 gives the effect of a three value drawing, although it does not go beyond the limits of outline and black. Thus, as will be shown later, the elaboration of details may often serve as a means of introducing desirable varieties of value into a drawing.

In the snail drawing the black is introduced to give color to the back, and the endings of the strong pen strokes that produce the black are so managed that no abruptness is felt where black and white meet.

Number 5 shows a treatment well suited to flowers of the type of our wild aster. The rays are made easily by one or two pen strokes of slight pressure for each ray. The sparing introduction of black in stem and smaller leaves serves the purpose of distributing the color satisfactorily throughout the drawing.

The iris shows a treatment of the flower which not only gives variety of color, but by the direction and character of the strokes hints at the modeling and textures of the parts. A few touches of dark are added to the leaves to preserve the balance of the drawing.

After copying any one of these drawings, the student should at once apply the method employed to original work from nature, selecting a subject suited to similar treatment. For example, a single rose would lend itself to the treatment of number 1, a dandelion or primrose to number 2, and so on.

PLATE 3

FREELY · COPIED · FROM · THE · HOKUSAI · MANGWA

1

2

3

4

5

6

PLATE 4

EX·LIBRIS

HAROLD·HOLT

EX·LIBRIS

HAROLD·HOLT

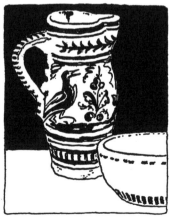
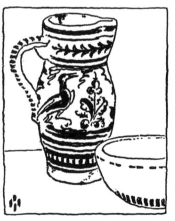

FOURTH PROBLEM

To apply outline and black to decorative arrangements of the types considered in the second problem

IN making the three initials here shown the outline composition of the O given in plate 2 has been used without change. Here is illustrated therefore how various distributions of dark can change the effect of a subject. In the first initial of plate 4 the veined treatment of the leaves is an important factor in the result. Another point to be noted is the outlining outside and inside the black letter, giving a white boundary of separation between the letter and the background. In the third version of the O this white line becomes a very important factor in the composition, since it prevents the confusion that would result if the black leaves were placed against the black letter. In the berries of the first initial the separating white lines and the small high light left in the largest berry are details of treatment not to be overlooked.

The middle initial shows perhaps the simplest treatment possible and that most generally applicable to decorative pen work in two values. Here the background alone is black, put in with a brush after everything has been outlined with the pen. The pen outlines can be plainly seen as the brush work here and there has not been carried fully up to the pen lines. This free treatment therefore is one to be chosen since it better preserves the pen character of the work than would a more precise treatment where the pen lines were entirely lost. The same kind of handling is evident in the leaves of the third initial, as well as in other examples in this plate and further on in the book. After studying these examples the student should experiment with his original initial composition in various ways of distributing the blacks.

Perhaps the most important point to note in the two book plate designs is the difference of treatment in the lettering. In the first instance, as the dark portion of the blueberry composition seemed to predominate, light letters were used. In the second case the composition seemed too light without the dark of the letters. Of course these two arrangements of the black and outline are not the only ones that would be satisfactory.

The student could, for example, try the effect of filled-in letters in the first composition, and he might experiment in varying the second by filling in all the berries, adding veins to the leaves similar to those in the first initial and leaving the letters in outline. Then he should try all the reasonable experiments he can think of in the distribution of dark and light in the original book plate design which he has already made in connection with the second problem.

The three treatments of the still life composition are identical except for the introduction of a foreground in the first and of a background in the second. The rich all-over ornamentation of the pitcher has been worked out with the pen so as to suggest considerable color, and the simple border designs of the bowl help to give it roundness as well as color, so that the third composition does not seem to lack color without further addition of dark. Further experimentation might be tried with this same subject. For example, both background and foreground could be painted in black, or the bowl could be made dark with ornamentation left white, etc. The student will find a rich field for experiment in outline and black in the realm of still life. It is advisable, however, to limit the composition to two or three interesting and well related forms.

FIFTH PROBLEM

To apply outline and black to a simple architectural subject

IN this plate the same outline drawing is shown with various treatments. The first is pure outline, but it should be noted that the tree masses are shown by broken lines. Certain minor details of the old house are also represented by slightly broken lines, but a contrast of line between house and foliage is needed to suggest the fact that the house is rigid while the masses of the trees are made up of moving leaves, which a firm unbroken line would fail to suggest. The large leaves of the weeds in the foreground are appropriately detailed in fairly complete outline.

Drawing number 2 typifies a way of introducing black which is often satisfactory. The roof of a house often may be effectively represented as the large dark of the picture. In the present instance the smaller roof gives opportunity for an agreeable repetition of dark, while smaller blacks are naturally distributed among the windows. A comparison of the treatment of the windows in numbers 2, 3, and 6 will suggest ways of getting legitimate variety, although it is well to keep a reasonable uniformity of treatment in a drawing, for it does not usually look well to suggest curtains at different heights in windows on the same floor.

In drawing number 3, where the right hand tree mass is made the largest dark, the balance is maintained at the left side of the picture by the dark windows, dark weeds, and the small tree mass behind the house.

Number 4 exemplifies a more reserved use of black, the largest mass used being in the foreground at the left, while still smaller spots are distributed at the right for the preservation of balance.

In number 5 the suggestion of the courses of shingles by free lines gives a gray value to the roofs. The addition of the blacks then produces in reality a three value drawing, as the effect is that of black, half-tone, and white. This is also true of number 6, where half-tone is produced by the delineation of the shingle courses on the sides of the house. It is instructive to notice the distinctive character of the effect produced where dark is introduced as sparingly as in this last drawing. The very slight hint of the individual shingles in number 5 and number 6 should

be observed. Much more elaboration of such details would be liable to result in unpleasant spottiness in drawings of such simple treatment as these. In making a study of this series of drawings the student is advised to consider each one carefully and critically *with all the others covered.* He can then see each at its best and make up his mind as to the merits of each treatment. After making copies of such treatments as he prefers, the student should apply the knowledge thus gained to the rendering of a sketch of his own. To translate a photograph of a simple architectural subject into terms of pen outline and black is another good way of putting the problem.

PLATE 5

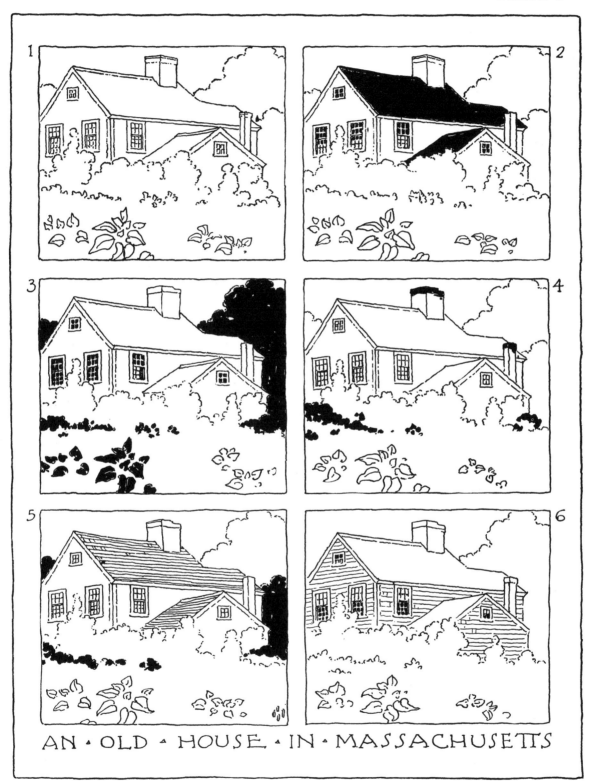

AN · OLD · HOUSE · IN · MASSACHUSETTS

SIXTH PROBLEM

To apply outline and black to a figure subject with accessories

PLATE 6 shows four ways of distributing the darks in the same outline composition. It will be noted at once that freedom has been used in the introduction of pattern wherever it was needed, whether in wall, chair covering, dress, or pottery. Thus considered, a drawing of this type presents great possibilities of variation, and the four ways given are but suggestions for the student, who should try many other experiments along similar lines. Having made several new arrangements, he should compare them with great care, decide which are successful and why, and try to decide definitely what mistakes have been made in the less successful experiments.

The use of simple pattern produced by a combination of outline and black introduces to the student a decorative device for getting into a picture the effect of several values. In drawing number 1, while the mass of hair counts as black, the chair covering as a whole counts as a dark gray because of the stripes of white. The borders of the bowl on the floor, broken by small white spots, also give the value of dark grays. The same thing is true in the case of the dress in drawing number 3. If the student will nearly close his eyes, and look at these pictures held at arm's length, comparing the unbroken blacks with those broken by pattern, he will see how the latter become practically of lighter value when regarded as a whole. Numbers 2 and 4 show effects produced without the aid of pattern. Number 3 shows how interest can be given to a wall surface by the introduction of a simple stripe, in this case made by repeating three parallel lines.

In such experiments as this problem introduces it is well to confine oneself to the simpler patterns, for the designs themselves should be unobtrusive, their use in the composition being to give separation to the forms and to introduce the element of contrast.

Much of the work of Robert Anning Bell * (and also that of several other contemporary English designers and illustrators) shows the outline and black treatment of figure subjects. Study of such work will tend to free the imagination and to suggest the great possibilities of beauty that lie in the right distribution of darks and in the skillful play of pattern.

* Bibliography.

PLATE 6

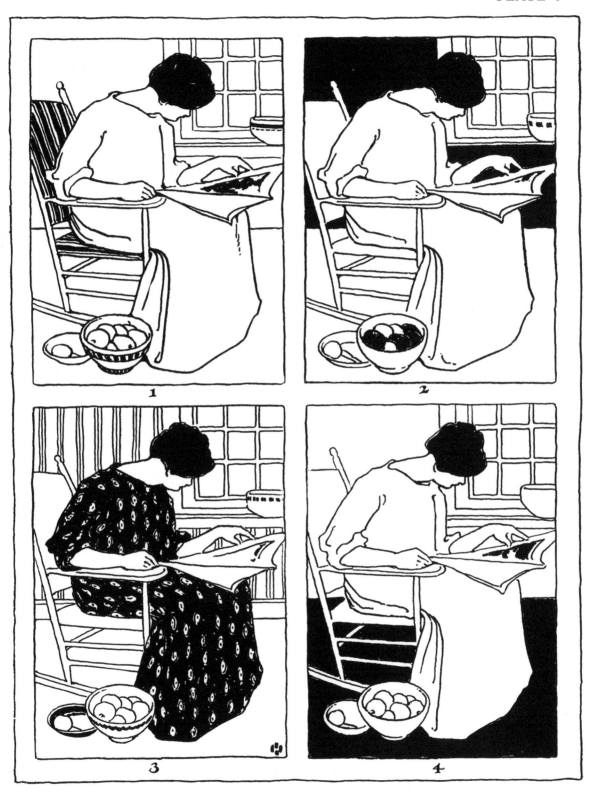

PLATE 7

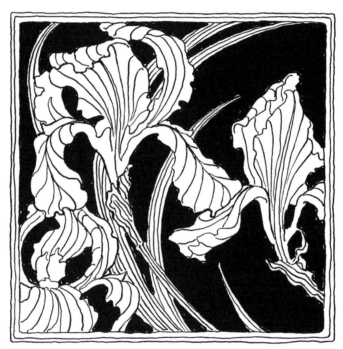

LINCOLN·SCHOOL
GRADUATION
EXERCISES

JUNE·TENTH
1912

SEVENTH PROBLEM

To make a cover design in outline and black, using a decorative floral panel with the necessary lettering

IN many schools the designing of a program cover is a problem of regular and not infrequent occurrence. This exercise therefore is an excellent one for high school students. The best way to present such a problem to a class is in the form of a competition. All members of the class may be required to make the design, as a regular art lesson, the best design being afterwards chosen by a jury and photo-engraved for final use upon the printing press. The choice of the flower motive may be made by the teacher or by each pupil, according to circumstances. Where possible it should be a flower having some relation to the occasion. In the case of a design for use at the graduation exercises the class flower would naturally be used, or if the class had chosen no flower, one appropriate to the month or season would suggest itself. If the program had to do with some personage closely associated by birth or otherwise with one of the European countries where the national flower is well known, the choice would be obvious. For example, a Shakespearian program might appropriately bear an English rose panel, or the Scotch thistle would naturally link itself with the name and writings of Sir Walter Scott. The choice of the fleur-de-lis for the cover shown in plate 7 was based upon the seasonal idea.

The arrangement of lettering shown in plate 7 is a typical one that may be followed in a majority of cases. The name of the school and the occasion appear naturally at the top in the larger lettering, while the date at the bottom makes a good subordinate and balancing mass. The relation that the width of the flower panel bears to the lettering above and below should be noted. While it is not necessary to keep the panel and lettering of the same width, a definite relation between the two must be planned. The diagrams of possible arrangements on p. 32 will be suggestive.

It should be noticed that in all three instances the width of the rectangle which contains the floral decoration repeats the length of one or more of the lines of lettering. This repetition of widths has a decidedly steadying effect upon the composition as a whole. All the space rela-

tions and the relative heights of the lettering in each of the two masses are matters for careful consideration. They give opportunity for the exercise of great nicety of judgment.

In working out an original composition for a cover design the best way for the student to arrive at success is at first to follow the general proportions of the design shown in plate 7. He may afterwards try the effect of making the heights of the letters greater or less than those in the plate, or of using solid letters in place of the outlines. It will be noted that the flowers here have been given an effect of light gray through the outlining of the veins, and a slightly darker gray has been given the leaves in the same way. The two weights used in the outer border lines are factors in the harmonious effect of the composition. If this design were actually to be used on a program it would be improved by being printed in some lighter value of ink rather than in black. For example, a grayish purple, a gray green, a brown, or a gray might be used.

EIGHTH PROBLEM

To make a cover design in outline and black by surrounding the panel containing the necessary lettering with a border varying in width to correspond with the margins of the type page

THE problem involves a somewhat more difficult type of composition than that required by the last problem. The difficulty lies in relating consistently the repeating motive to the various widths of the border.

The basis for determining the four border widths should be understood. In well printed books the margins are approximately in the proportion indicated by the figures below, where an open book is diagrammed. The margins may be wide or narrow, but they should bear this relation to each other. All the rectangular masses of type or "type pages" register; that is, are directly over each other in the closed book. A well printed folder generally follows the same plan of margining, so that the cover design for a folder may quite logically carry out the plan of spacing which good printing requires.

The rectangle occupied by the lettering in the design (plate 8) shows the size of the type page. What the margins of the printed page would be are shown by the spaces between this inner rectangle and the outermost line. The decoration therefore is an enrichment of what corresponds to the margins of the type page which would follow.

It should be observed that the darks of the background are all small in size and well distributed. No exact repetition of units occurs, but a general plan of repetition and alternation has been adhered to. Not all flowers will lend themselves to just the plan of arrangement which has been followed in this case with the crocus, but students who have some knowledge of design will discover several ways of satisfactorily distributing floral material in borders thus related to each other in width.

The beautiful borders designed by William Morris for his books of the Kelmscott Press are fine examples for study in connection with this problem. It should be remembered, however, that such designs are the "last word" in a type of design of which plate 8 gives a very elementary example.

PLATE 8

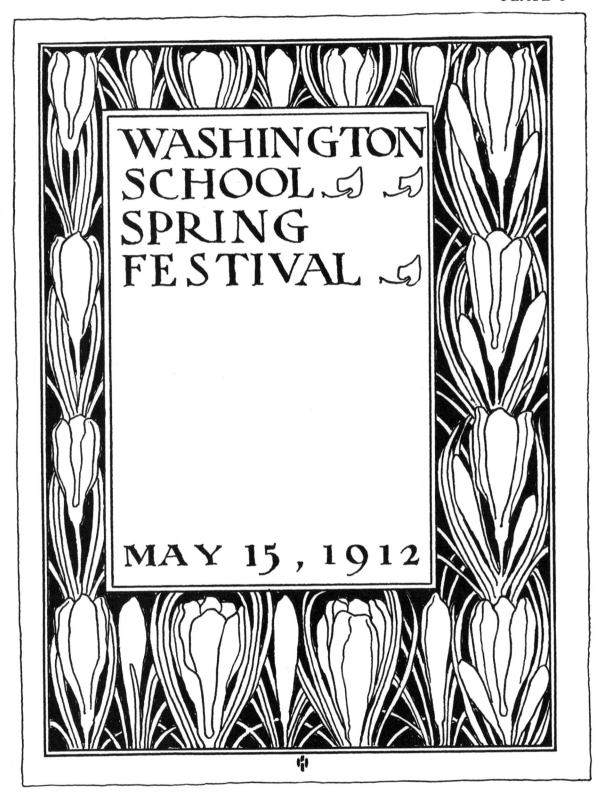

WASHINGTON SCHOOL SPRING FESTIVAL

MAY 15, 1912

PLATE 9

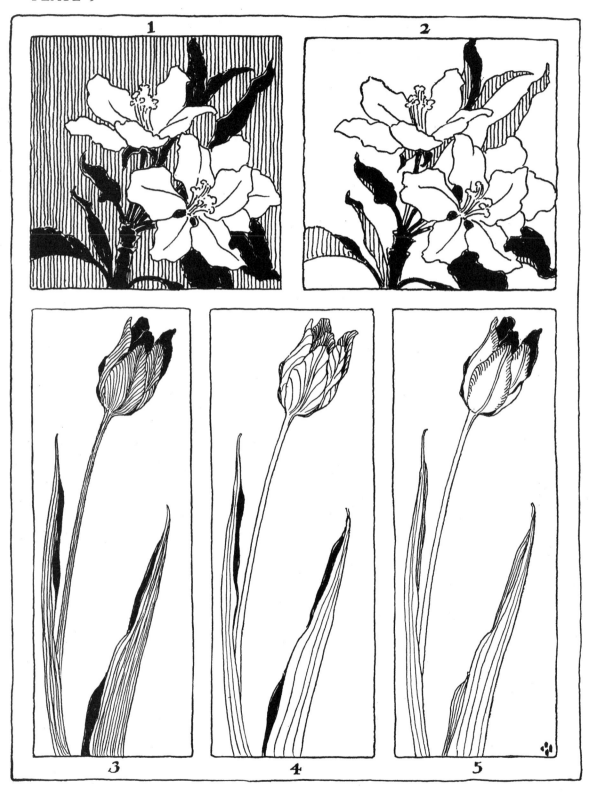

NINTH PROBLEM

To draw flowers in outline, black, and middle value

THE new point in this problem is the frank introduction of a middle value or "half-tone," by means of parallel lines which do not represent details or texture. The reason for the gray background in drawing number 1 lies in the desirability of representing white flowers more convincingly and dark leaves with less crudeness of effect than is possible without the middle value behind.

It is obvious that in drawing number 2, where the white flowers are seen partly against the white background, they have less of an effect of whiteness. The use of a gray for the under side of the leaves introduces the third value, which serves the purpose of giving the refinement which a drawing in outline and black alone cannot possess.

It will be instructive at this time to refer to the previous plates for the purpose of reconsidering the means by which the effect of another value has often been obtained through the introduction of blacks broken by pattern or otherwise (plate 6), or by closely drawn lines which suggest details (plates 5, 7, etc.).

Drawings 3, 4, and 5 of plate 9 do not differ essentially in method from such foregoing examples, but they are introduced here to illustrate various ways of interpreting the same floral subject in three or more values with lines that are in themselves significant of venation and modeling. Comparison of the three renderings of the tulip should suggest to the student very definite methods of interpreting flowers. The tulip itself presented certain facts of color contrast, as well as facts of form and of detail. These facts have been variously stated in the different drawings. In each, however, the inside of the flower is shown darker than its outside, and in each the same thing is true of the leaves. Probably drawing number 3 suggests most nearly the actual color values of the flower. Number 4 introduces a light gray beside middle value and black, and this also is true of number 5.

The two distinct methods of introducing a gray which are illustrated in this plate should be distinguished sharply from each other. Both are

legitimate in decorative pen work, but the method illustrated by the last three drawings is to be preferred as a rule. It is a method by which the different parts of a subject can be given individuality of texture and modeling as well as of color. The method employed in the background of number 1 is appropriate to a background because vertical lines thus used remain "quiet." Oblique or curved lines would, on the contrary, express motion and be out of place there. In drawing number 2 the vertical lines on the leaves express value only. Here they might be so drawn as to express also the modeling of the leaf, but there would be danger of confusing the effect in a drawing with so many different irregularly shaped parts. The use of the vertical lines tends to simplify the composition; moreover, the flowers are of sufficient interest to make it advisable to treat the leaves as subordinate to them.

TENTH PROBLEM

To render still life or still life with plant forms in several values

NO new principles are introduced in this problem, although the results shown in plate 10 are quite different from any in the preceding drawings.

It will be seen that drawings numbered 1 and 2 are the same except for the backgrounds, the treatment of the little jar, and a slightly different rendering of the back of the upper book.

The careful drawing of the painted ornament of the teapot serves to give it color and roundness. A point to be observed is the use of the dotted lines in the top, where a full line would have been confusing, and again to indicate the line of juncture of spout and body, where a full line would have produced too distinct a separation of the parts.

The upper book had a black leather back with lines and lettering of gilt. The rendering of this in drawing number 1, where the pen lines show, hints at the light and shade, while in number 2 the black is put in solidly. The edge where the black was worn off is shown in each case by a not too regular line of white. The student should note carefully the way the mottled paper is treated to suggest the various sized roundish spots in perspective.

In the lower book the rendering aims to suggest the value and texture of the silk brocade with which the book was covered. The labels were of dark leather bearing lettering of gold, the effect of which has been rendered without any attempt to draw individual letters.

The principal differences between the two treatments of the little jar is of course the difference of direction of the lines in the lower portion of the body. There is, however, a difference in value in the two renderings of the upper glaze. The reason for the lighter value in drawing number 2 is that a greater difference might be shown between the jar top and the black background for the sake of variety in the picture. In both drawings a slight suggestion of shadow has been given to the jar by pulling the parallel lines into a nearly solid black where the surface would be turned away from the light.

In drawing number 3 the basket work, being quite literally represented, gives the effect of a light gray value. The dark glass behind is rendered in vertical lines made with enough pressure to unite them in nearly a solid black. The careful drawing of the high light at the top of the jug and the leaving of the slight reflections below serve to declare the material. The interpretation of the grass heads to suggest texture and roundness, while keeping the value light, is a point to be studied carefully. A similar treatment is not infrequently called for in nature subjects.

The gray value for the horizontal surface on which the vase stands in drawing number 4 is one point of difference between this drawing and any other that has been studied thus far. It may be said in passing that, generally speaking, the student will find it harder to introduce foreground grays than gray backgrounds. It may be well to plan to cover horizontal surfaces with a gray only when such surfaces are comparatively small in area. The rendering of the vase aims to take advantage of its peculiar markings and texture in giving variety of value and a hint of modeling. The use of the dot should be noted, but it should generally be sparingly used. The iris is rendered by the same principles as those used in the tulip drawings, plate 9. Drawing number 4 presents no new technical considerations, but is given as an example of another application of methods already discussed.

PLATE 10

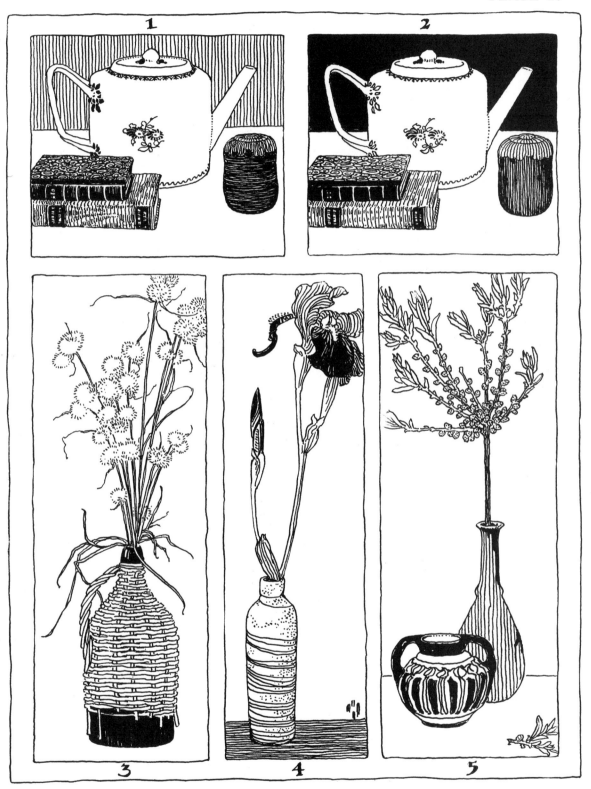

PLATE 11

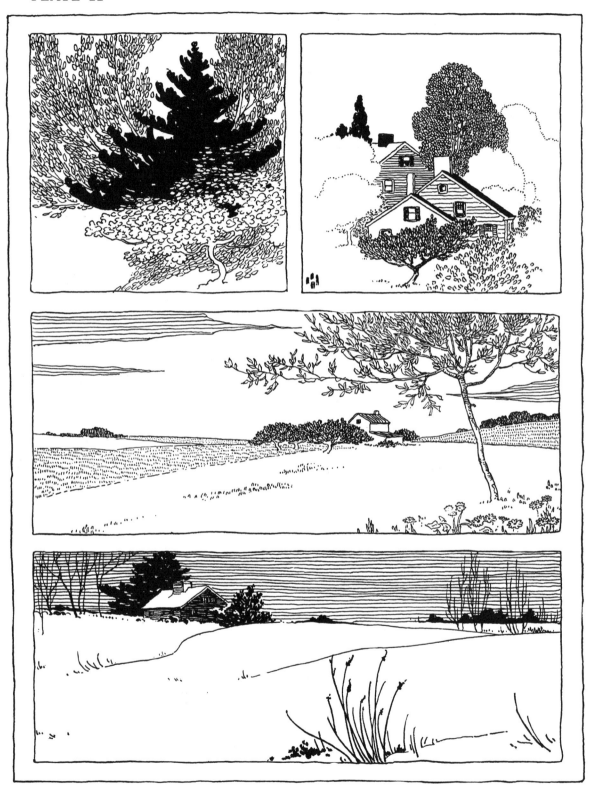

ELEVENTH PROBLEM

To render typical landscape subjects in several values

IN translating a group of trees into decorative pen rendering, it becomes necessary to find several contrasting conventions which suggest the characteristics of different types of trees. The first drawing in plate 11 is presented as one solution of this frequently met problem. Treating the pine in silhouette gives a leading dark to the composition and also satisfactorily suggests the color and mass of the tree. Behind are drawn the birches radially related in their main lines of growth, and so treated as to give a light and leafy gray. While the shapes which compose this gray are not literally those of the birch leaf, nor are the sizes of the leaves right, yet in a generalized way the character of the tree is fairly satisfactorily shown. The essential points to be brought out in such treatment are the characteristic growth of the masses, a value suggestive of the facts of color, and a texture suggestive of the shapes and growth of the leafage.

The blossoming bush in the foreground introduces a value lighter than that of the birches, a suggestion of many radial flower forms, and a spreading mass which contrasts effectively with the other tree shapes of the picture. Below the bush is placed a gray of about the value of the birches in the background, but made up of leaf-like shapes differently placed. This gray is not intended to denote any particular type of growth, but rather to serve as a contrasting note of color for the bush, just as in nature the undergrowth seldom declares itself definitely, when one is looking at a group of trees.

In this drawing, as in parts of all of the others on the page, the white paper is allowed to stand for the ground. In this way is avoided an unpleasant complexity and lack of clearness which is almost inevitable when many closely related values are placed against each other. The trees are the subject. Other things are omitted so that the trees may dominate.

The second subject might be named "The Village." Hence the houses receive full attention, while several of the surrounding trees are merely defined in contour by dotted lines. Enough are fully drawn to give

reality to the scene and to contribute contrasting shapes and values to the picture. Three distinct types of trees are in evidence: the tall dark trees at the left, which may pass for poplars; the ovoidal gray tree at the right, and the apple tree in the foreground. The leafy suggestions at the right and left of the apple tree are intentionally less defined in shape and character. They serve as means of rounding out the composition. In this picture at least five distinct values are used besides black and white.

The central landscape is unique among the examples thus far presented in that it introduces no blacks. This at once places the picture in a light key and gives it a spring-like appearance, which was the intention. The treatment of the sky is to be noted, the gray representing the blue while the white stands for cloud masses. The distant tree masses have been kept quiet by the use of nearly vertical lines. The almost patterned treatment of the newly planted fields introduces a bit of technical variety which contributes much to the interest of the drawing. The size of the foreground tree gives opportunity for a rather literal outline rendering of the leaves and branches, and a few detailed foreground leaves and field daisies do much to give perspective to the drawing.

The winter landscape at the bottom of the page depends for its snowy effect upon the gray sky, the dark masses of evergreens, and the leafless trees.

Instead of copying the landscapes in toto, the student who prefers to do so may in each case select a portion of the picture, thereby making a set of new compositions. This exercise should then be followed by efforts at making similar compositions from new material. This material may be photographs from nature or the student's own sketches. In any case he should select, eliminate, and rearrange the forms for the sake of good composition.

TWELFTH PROBLEM

To render a figure subject in several values

A FIGURE with its background, whether indoors or out-of-doors, gives the widest opportunity for various effective forms of decorative pen work. In the first place the costume of the figure may be given any one of an infinite variety of patterns; then the details of the costume — trimming, jewelry, millinery, hair-dressing, etc.—all offer many possibilities of treatment. When a landscape background is added the possibilities are doubled. The free natural pattern of leafage and cloud forms and the embroidery-like design of field or flower bed may be translated into numberless forms of pen play.

The dual treatment of the lady of olden days suggests what may be done in the way of transforming a composition by slightly changing the costume treatment and by the use of different surroundings.

The student may profitably take each of these compositions as a basis for experimentation in varying the effect by change of patterns and of values. For example, the wall could be made black, broken by pattern, and the floor could be white or broken by the lines of boards or tiles, or by a patterned rug. The figures of the gown could be made different, larger or closer in distribution. Finally the foliage mass without could be made up of larger or smaller leaves, thus producing a lighter or a darker value, and the sky could be made without clouds or with differently formed clouds. Having once started to experiment in such variations, the student will begin to realize that he has one key to the world of artistic invention, for new creations in the last analysis are often found to be skillful rearrangements or new combinations of materials that have been used many times before. The student should realize, however, that exercises in rearrangement such as are here advocated are but a means of learning. Before one has a right to consider his drawing *original* he must be able to work out his own compositions. While such compositions will show the influence of definite study of others' work, they should in no sense be conscious adaptations or imitations of another's productions. The student who works from nature, and from imagination and memory at

35

the same time that he is studying the language of art as used in the works of artists, need not fear any danger of becoming an imitator in any wrong way; for he will learn the language of art for the purpose of expressing his own ideas of form, and the language will become his own to the same extent that a spoken language becomes one's own through its natural use.

The second composition worked out with a variation of values simply adds another example to the one already discussed.

PLATE 12

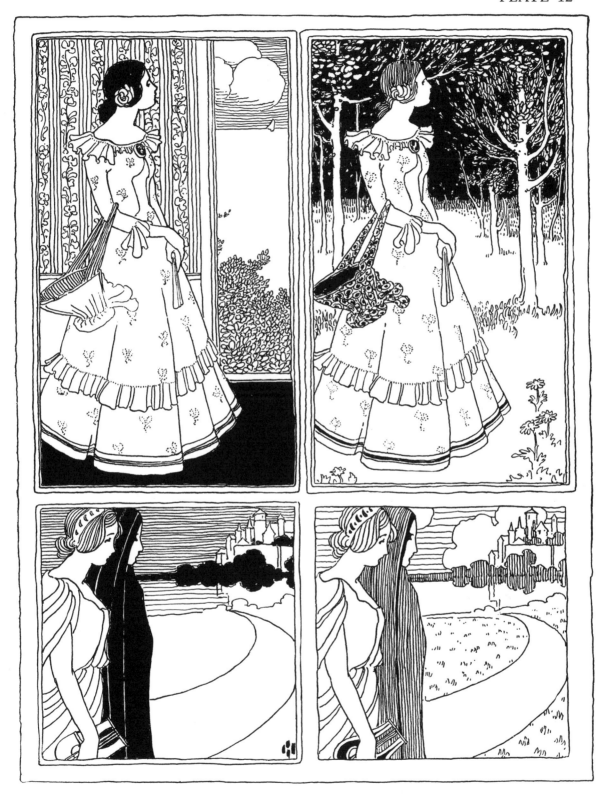

PICTORIAL PEN DRAWING

GENERAL STATEMENT

IN Decorative Pen Drawing which has thus far occupied our attention, the third dimension, that of thickness, has been disregarded, at least so far as it brings in the problem of light and shade. Outline, which is a conventional means of expressing the limits of form, has been the basis of all the work. The values were introduced to express contrasts of color. The one aim was simply beauty of arrangement—decoration—even though we employed a variety of subjects as motives.

The aim now is more inclusive, for we shall still aim for beauty of arrangement of line and value, although the arrangements are primarily pictorial in character. We have, however, opened our eyes to the greater variety of values produced upon objects and surfaces by the play of light and shade, the representation of which is considered in the following problems.

The training of the more formal decorative pen drawing should have taught the student something of discrimination as to quality of line. In the freer and more sketchy use of the pen which the following problems involve, the handling, while more cursive, shows none the less regard for the quality of each touch. A successful series of rapid strokes, the "carefully careless" pen work, is far more difficult than the more formal kind where all the lines are drawn deliberately. So let the student be on his guard. Let him realize fully what he is aiming for before he begins, and let him be prepared to try again and again and yet again before he can hope to arrive at a good style in "free" pen work. True freedom can result only from surety or knowledge.

A good pencil drawing was stated to be the basis for a good pen drawing at the beginning of the problems in decorative pen work. In pen drawing with light and shade a correct pencil foundation is just as important, and the more free and sketchy the final ink treatment is to be, the more sure should be the pencil outlines of both objects and shadows.

PICTORIAL PEN DRAWING

THIRTEENTH PROBLEM

To render simple still life forms in light and shade

THE first drawing of the cardboard box with its cover gives an example of a semi-formal treatment. Rather slowly drawn parallel lines are used in producing both shades and shadows. Color values are not found in this drawing, the different degrees of darkness being representative of light and shade alone. Cast shadows are darker than surfaces in shade, and some slight gradations are to be noted. Touching in the ink outline is the last step in making the drawing. It is put in with a slightly broken line and omitted where the masses of shade or shadow suffice to define the forms. This omission of outlines is a distinct departure from the practice in the work heretofore. The student should see that it helps to give an effect of reality, of light flowing over the objects, and that it is a treatment in harmony with our present aim of representing the impression of light and shade.

The second drawing of the same subject differs from the first only slightly, but is a trifle less obvious in its method. While the lines on the sides of the cover in the first drawing are straight, of equal length, and follow the surface, in the second drawing they are more informal, curve slightly, and for a little distance two short series of strokes are used instead of one series of the full length. This breaking of the values into several series of short strokes of not too even length is pursued throughout this drawing and marks the distinct difference in handling between this drawing and the first. Learning to produce a practically even value by means of freely drawn short lines, their ends meeting but not overlapping, is a necessary technical achievement to acquire at this stage of practice.

The old jug so placed that it requires but little shade is rendered by a handling conforming to its curved surface. The slight curving of the

lines which make up the shade is important, not only because it helps to suggest the desired roundness and character of surface, but also because it introduces another element of contrast between the treatment of the jug and the treatment of the shadow. Hence the lines of the shadow on the floor while harmonizing in general direction with those upon the adjacent part of the jug, contrast with them in length, thickness, quality (the result of a slower stroke), and straightness as opposed to curvature. If we now analyze the shadow of the handle upon the jug we shall find that while its lines are naturally slightly curved and finer than those of the shadow on the floor, their quality is similar. Thus by repeating not only the value, but the quality of line in opposite parts of the drawing, a unity of effect is obtained. Both shadows have enough in common, but the shadow upon the curved surface quite logically is made up of curved lines. The passage from this last shadow to the shade of the handle should be carefully noted. To appreciate more fully the foregoing reasons for deciding upon the handling employed in this simple object, the student should take a similar object and make experiments in translating it into a satisfactory pen drawing made up of shade and shadow. He will then see the difficulties that lie in the way of arriving at a simple treatment. Most people find the simple way of doing things only after trying many indirect ways. To shorten the search where possible is the part of good instruction; still each student must rediscover his methods and their reasons if they are to have meaning and vitality.

A single book, preferably an old one, presents a perfect subject for the pen. The drawing given should serve as a type for several studies of single books varying in shape, in details, and in the position chosen for representation. The points of handling to be learned from the example given should be easily seen by the student who has followed the comments upon the three preceding drawings. Note carefully the importance of the contrast of direction of lines used in expressing the leaves and the edge of the cover upon the shade side. Note also how the suggestions of the ridges upon the back of the binding are but partly defined, and finally note how slight a factor in the drawing are the outlines. It is a drawing of shapes of shades and shadows.

The group of three books, apparently carelessly tossed together, was in reality most carefully selected and placed. The selection was made to include variety of size, proportion, character of binding, and color.

PLATE 13

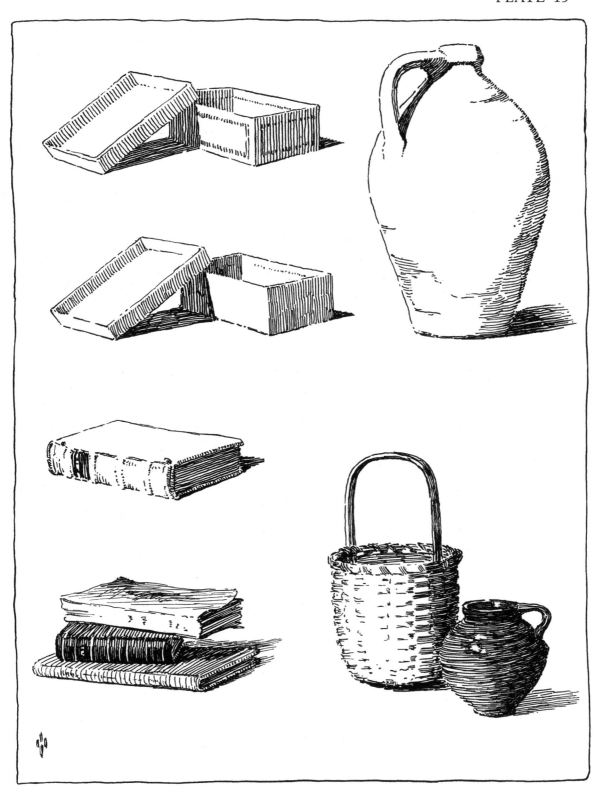

The placing was the result of experiments, the aim being a pleasing distribution of values, including the consideration of the shades and shadows. In this drawing, therefore, we concern ourselves with the interpretation of both color values and the values resulting from shadows. The technique throughout is freer, a trifle more sketchy than in any of the preceding subjects. The graduated delicate gray of the top book, with its bent paper cover, is a gray produced by rapidly drawn lines. The lines making up the cast shadows of the lower book are not dissimilar in character, though they are cross-hatched at a slight angle. A slight amount of cross-hatching also occurs in the top of the dark book and again in the shadow upon the lower book. While the beginner in pen work is advised to avoid the crossing of lines as a means of darkening his values, the occasional appropriate use of cross-hatching to give definitely contrasting effects is a desirable technical device.

In the last drawing of the plate the basket and glazed jar are placed together as a study of contrasting textures. It should be noted that the details of the weave are most in evidence in the part of the basket where a transition is made from the light side to the shade side.

The rather long, fine, crossed lines used in the jar in connection with its high lights serve to make up the suggestion of the somewhat uneven green glazed surface which the object itself presented.

The six drawings given in plate 13 may well serve as types of such still life as the student should practice. Similar but different subjects are within the easy reach of anyone. Some subjects suggested are strawberry baskets, various boxes which contain cereals and other groceries; quaint jugs, jars, pitchers, bottles, demijohns, flower pots, and simple kitchen dishes; basket forms of all kinds; simple pottery; quaint old books, and magazines.

PLATE 14

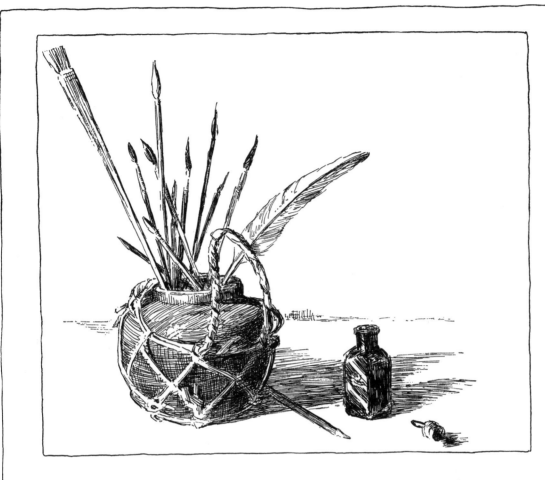

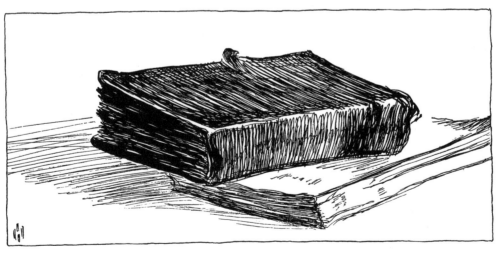

FOURTEENTH PROBLEM

To render still life in a free manner *

THE lower study of plate 14, being the simpler and bolder, is recommended for study first. In subject not very different from the book group of the previous plate, its treatment is much more flowing. The sketchy handling is in keeping with the somewhat dilapidated condition of the old books. The lines conform in general direction with the surfaces of the leather covered book, and the values and drawing of significant details have been carefully kept. Various touches which may seem to the student almost irresponsible will be found to have definite meaning. It would be well before copying this drawing to hold it at arm's length and study it with partly closed eyes to grasp thoroughly its general effect so far as values are concerned. Then an examination of the various parts under a magnifying glass would reveal the component lines. Experiment and practice alone can give the ability to handle the pen so as to produce such a drawing. No attempt should be made of course to imitate the *exact* handling. Rather the effort should be to make a drawing correct in values and in its suggestion of characteristics with a handling of similar effect.

In the jar of brushes, ink bottle, etc., the effort has been to transcribe the values of the various objects rather literally with pen lines so used as to appear unstudied in handling. Considerable careful analysis on the part of the student will be required if he is to grasp the spirit of the pen work. Perhaps the only actual technical departure in the two drawings of this plate from what has preceded is the venturing upon crosshatching at practically right angles. As a rule this is difficult to manage successfully, though knowingly used it may give a good result.

* If the student desires to do so he may omit this problem and proceed at once to the fifteenth.

FIFTEENTH PROBLEM

To render plant life pictorially

DRAWINGS 1, 2, and 3 depend for their effect almost as much upon the nice delineation of the boundaries of the shadows as upon the drawing of the contours of the forms, or the pen technique employed. In the first subject the gradation of the shadows is an important point to be noted. A gradually increasing pressure has been brought to bear upon the pen in each down stroke which makes up the shadow. A study of these lines through a reading glass will show clearly the method that has been used. The exact placing of the details in the half light and their gradual diminution in strength and disappearance as they pass into the full light are other factors that make up the interest of the interpretation of this subject in sunlight and shadow. Only a hint is given of the leaf of the plant. It serves as a third spot in the composition, but is purposely neglected in details in order to emphasize the heads with their orderly arrangement of details.

Two poppy pods, drawings 2 and 3, are given so that different ways of handling a similar subject may be studied. In number 2 the lines which make up the values are all deliberately drawn, but with various degrees of pressure. The result is direct, but more formal than number 3, where more and finer lines are used. In this latter example one is impressed more with value and less with the lines themselves, and the result as a whole is the more refined and truthful on this account.

In number 4 the nasturtium leaf is introduced as a background for the flower. The cross-hatching therefore serves as a foil for the simpler and more descriptive handling of the flower, which is the real subject. As an interpretation of the leaf alone such technical means as are used would be very unsatisfactory, but as the flower is completely rendered to express form, texture, color, and light and shade, it is quite proper to subordinate the leaf, which otherwise might usurp undue attention.

In drawing number 5 is found an example of a subject which lends itself admirably to exceedingly simple pen interpretation. Indeed the drawing is scarcely more than an accented outline, though the treatment

of the spherical blossoms does introduce a hint of shade, and for the sake of harmony shade is also barely suggested in two or three places on the grass blades. Much of the effectiveness of this drawing lies in the variety of weight of the strokes which form the spiny spheres.

Drawings numbers 6 and 8 need little comment. They are simply free outlines with gray or black added to give contrast enough to separate or explain the forms.

In number 7 is shown a rendering of the fleur-de-lis in which the aim was to express form, color, textures, and light and shade, with considerable attention given to the various details of the flower. While all the lines used are comparatively fine, careful inspection of the drawing will reveal the fact that there is a good deal of difference among them. Comparison of the dark parts of this drawing with the darks of the nasturtium above will show that while the latter are produced with a few wide touches the darks of the fleur-de-lis are composed of finer lines closely knitted together. The result is more expressive of the rich velvety texture of the flower than any that coarse lines could produce. A drawing like this is more the result of feeling than of detailed reasoning, although it ought to be easy to justify by reason any point of the treatment if it is right. If the student copies this drawing or the others, he should be perfectly clear as to the meaning of all the lines used, the reason for their directions, weight, lengths, and qualities. If he fully appreciates the reasons, he should gradually work toward the degree of mastery where his pen will move almost instinctively and more and more express the sympathy and understanding which he should feel for the subject he is drawing. For no drawing can have freedom, charm, or style if it is the product of the reason alone.

PLATE 15

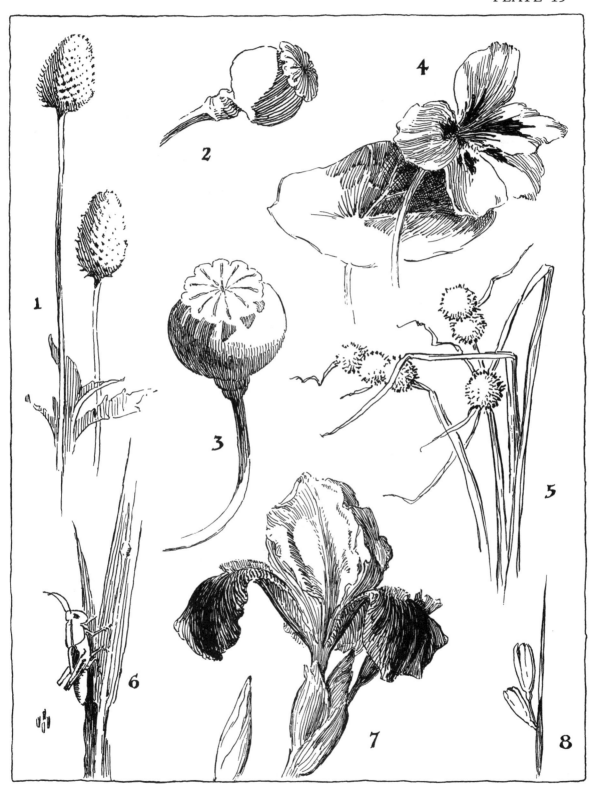

PLATE 16

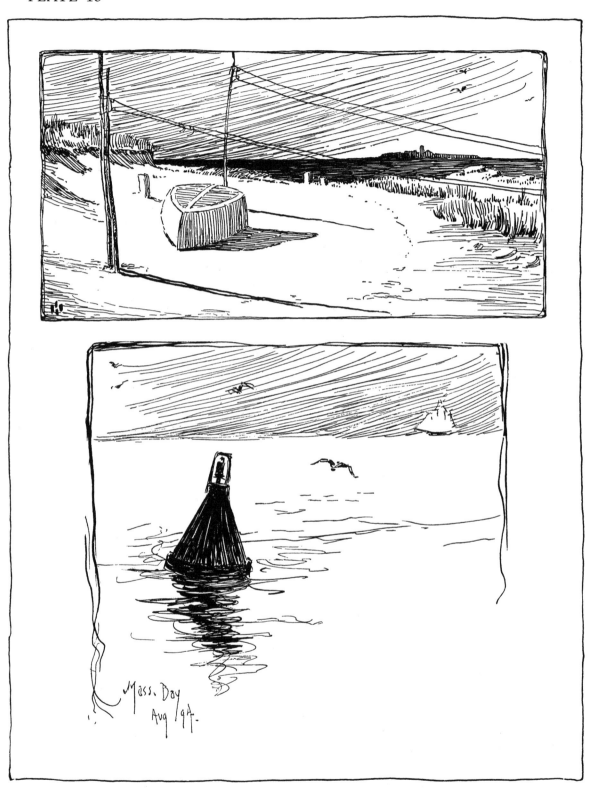

SIXTEENTH PROBLEM

Simple outdoor subjects

AS an introduction to outdoor sketching, subjects involving neither trees nor buildings are presented for study in plate 16. The chief difficulty in all out-of-door work lies in the necessity of limiting one's efforts to a very small bit of the scene that nature spreads before us. The temptation always is to attempt too much, and the problem lies not only in the selection of a small portion of the scene suitable for a sketch, but also in reducing that portion to very simple terms. While the pen lends itself to the close delineation of details, only significant details should be delineated.

The first subject, which might be named "On the Beach," has been selected and treated so as to exemplify clearly certain essentials of effective pictorial composition. Looking first at the values, we see that the sandy beach gives a large central light area leading up to the distant line of sea, which contributes a contrasting dark mass which is graded from black to a dark gray. Sky, grass, and shadows serve to introduce the half-tones which are needed to bring the whole into restful relation.

The upturned boat with its shadow gives a leading form of interest near the center of the picture; the poles with their lines are subordinate but related objects of interest, contrasting in their attenuated character with the low mass of the boat. The distant land and birds serve as added though minor interests to give balance to the right half of the picture. Examining the pen work, we find that the more exact and formal treatment has been allotted to the boat, as befits a constructed form as contrasted with the freer forms of nature. The most flowing lines are appropriately found in the sky, while the direction of the sky lines not only gives movement, but offsets the direction of the ropes, the shadows on the beach, and the slanting line of the beach itself. It will be noticed how well the treatment of the beach grass (not too fully detailed), with its short, crisp strokes, contrasts with the horizontal lines of the water, and again with the free, light, generally horizontal lines of the shore at the right. The slight suggestion of a few stones breaks the monotony and leads the eye pleasantly into the picture. While this is but a partial

statement of the reasoning that had gone into the sketch, it should prove sufficient. The thoughtful student in copying should be able to criticise his own effort and to carry some of the lesson over into original work.

The very free but simple treatment of the second subject, that of the whistling buoy, now needs few comments. The only new type of handling occurs in the broken reflection expressing the movement of the sea. The effectiveness of this simple sketch lies partly in the fact that its one leading dark is also the leading interest of the composition, the distant ship and the wheeling gulls giving the subordinate notes of interest. The purely artistic interest of the whole subject—its arrangement of line and value — is perhaps seconded by a certain sentimental interest. The lonely moan of these ominous ocean guards must have impressed all who have heard them. Even in fair weather as they rock restlessly they carry to the mind the sinister suggestion of storm and the dangers of the sea.

SEVENTEENTH PROBLEM

The rendering of trees in winter and in summer

THE first subject, the white birches, is kept light throughout to give to the drawing an impression of delicacy in keeping with the character of these graceful trees. The darks used to express the shadows in the foreground, the spots on the trunks, and the pines in the distance are so small in area that they only serve to accentuate the light quality of the picture as a whole. Things especially to be noted are the almost total omission of outlines, the expression of the trunks by the short parallel lines that carry to the mind the suggestion of the smooth wrapping white bark, and the broken and almost dotted lines used in the smaller branches and in the trees of the middle distance. The use of vertical lines in the distance gives a needed contrast of direction with the horizontality of the mass, and the broken and not too even character of these lines produces slight variations of value which are in keeping with the mystery of a mass of distant forest. The way that the distance and the foreground have been tied together and yet kept distinct is a point for the student to appreciate, as is also the simple means used to indicate modeling in the foreground and in the middle distance.

Contrasted with the birches, the character of the trees in the right hand picture at the top is indeed marked. Careful comparison of the two drawings will reveal the fact that the actual differences in handling are not great, but the great points of dissimilarity are in the actual shapes of the trees and their manner of branching, and in the value relations. The effect of a rather rough dark bark is given in number 2 as contrasted with a smooth light bark in the birches. It is interesting to note that the secondary object of interest of this picture, the group of distant houses, is light in contrast with the dark trees, the real subject of the picture. The secondary spot of interest in the picture of the birches is the dark spot of the distant pines, making a contrast in value with the light birches. While no rule can be made in regard to such a matter, it is nevertheless an element in the effect produced. The treatment of these two drawings of bare trees and distance is about as simple as it could be, and may serve

53

as a type for kindred subjects which the student should, without great difficulty, compose, for himself.

The purpose of the two foliage studies in the center and right of the plate is to illustrate two distinct ways of translating a tree in sunlight into pen and ink. In the first instance the color of the tree in light is represented by a medium gray, while the shadow masses are shown in dark approaching black. In the second instance, the color of the tree in light is translated white, the contours of the tree being warily outlined. The shade masses are then shown gray, which places the whole picture in a high key. The small note of black in the shadows on the ground only serves to heighten the effect of lightness, as was true in the case of the composition of the birches. Whether one chooses to key a landscape to the pitch of number 3 or to that of number 4, pen drawing by its limitations makes it advisable generally to eliminate from a picture the representation of the variations of value of ground and sky. While it is possible for a skillful draughtsman to include these values, there is generally a question as to whether he thereby improves his picture; and a beginner courts failure if he refuses to simplify his task by such frank omissions as are here exemplified. Drawing foliage is one of the most difficult problems of pen drawing. To suggest leafiness without drawing the leaves, to get the effect of modeling and form, and at the same time to avoid all rigidity of outline, to do all this in a free and unaffected way requires full appreciation of the ideal sought and much practice. The student will do well to practice small bits of numbers 3 and 4 over and over, until he gets the right swing of the pen. Let him study, most carefully, the treatment of all the edges of the masses of light and of shade, and above all let him preserve exact drawing in shapes of shade masses and in the spots of light seen through the tree. In number 5 is presented foliage of contrasting types. The treatment is somewhat freer than in the two previous drawings, and suggests trees of smaller size seen nearer, so that the leaves are more in evidence. Different color values are suggested in the different trees as well as different types of growth and of foliage. Many of the things which have been said in connection with the previous subjects apply equally well to this. There are also several bits of handling that are different from anything heretofore given, which the student should be keen to notice and appreciate the reasons for.

The picture of the haystacks may perhaps seem a little aside from the main problem of this plate. It does, however, involve the drawing of a

PLATE 17

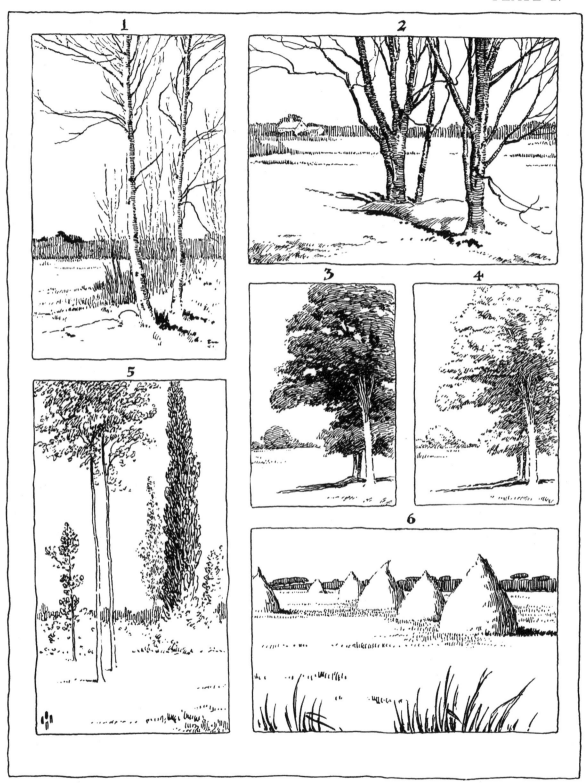

distant line of trees, and on the right expression of these tree masses much more depends than might be supposed, until one considers what would become of the picture if the distance were eliminated or reduced to an unbroken horizontal line. An important point in the composition of this distance is the careful definition of certain tree forms which rise above the lower mass, and an important point in the handling is the darkening of the forms by the pen pressure brought to bear at the lower ends of the strokes. By this means a variation of value is produced which gives just enough modeling to the masses.

EIGHTEENTH PROBLEM

The drawing of buildings

IT must be borne in mind that in the free treatment of buildings and architectural subjects the preliminary pencil outline cannot be too correctly and definitely drawn. Not only is this important in the large masses, but in the details such as windows, doors, etc. Where so many outlines are omitted, as in the pen sketch of the old New England house, there is great danger of losing the sense of correctly placed shadows unless a perfectly sure pencil drawing exists as an underlying scaffold, and this pencil drawing should include the outlines of the shadow shapes.

The simplicity of effect in this drawing results from the massing of the darks in the background foliage and from the fact that a large central portion of the drawing has been kept light. If the picture is studied through half-closed eyes it will be more clearly seen how the light of the roof and chimney ties in with a light in the bush at the corner, which in turn leads into a large light portion of the foreground. The gray parts of the picture are also kept comparatively unbroken, although a subordinate streak of light cuts the half-tone of the grass at the right, and the gray of the house at the left is enlivened by the accents of dark and light in the windows, etc. This drawing serves well as an example of the useful general rule that a satisfactory composition may result from using a large mass of dark with a large mass of light and enough gray to harmonize them. Such a rule, however, is useful only as a basis of experiment; the principal masses are never unbroken and should not be too obvious, and besides, the success of the result depends much on the judicious use of subordinate darks and lights.

In the pen work of this drawing a coarser pen has been used in the darks of the foliage than in the house, this device helping to accentuate the contrasting characters of leafage and house. The treatment of the windows and blinds is something to be most carefully studied, for while much detail has been omitted, yet the essentials of the frames, sashes, small panes, curtains, and blinds have been carefully suggested. To express such details adequately, but so that they are properly subordinate to the whole sketch, is the aim to be kept in mind.

In the drawing of the English half-timber house a variety of materials and textures is suggested by various technical devices. The principal roofs are of slate, while the roof of the porch over the door is obviously of thatch. The drawing of the courses of slate in free broken parallel lines conveys the impression of a rolling surface produced by the sagging of the framework, and a few added indications of individual slates in the vicinity of the gables serve to complete the impression. Where brick exists only a few of the forms are drawn, which is true to the impression one receives in looking at a brick surface, for the eye takes in but few of the individual bricks at a glance. In fact one of the great charms of a pen drawing lies in the skillful suggestion of texture or material by the simplest possible means. A drawing in which details are over-elaborated does not carry the impression of light and atmosphere as well as one where much is suggested by slight means. Careful study of the drawing under discussion will give to the student ideas of how to suggest much by the paper alone. For example, it will be noted how a few judicious indications of light shadows suggest the flowers and foliage of the foreground. This drawing is also purposely neglected at the corners (or is vignetted), so that the interest of the sketch may be more concentrated upon the house itself. The leading dark of the drawing is comparatively small, but a large light, although somewhat broken by details, occupies so much of the composition that it imparts a very sunny effect. The gray of the roofs and tree mass at the left harmonize and solidify the picture so far as values are concerned.

A tower of a country church is the subject of the third drawing. Foreground, foliage, and the indication of the body of the building are therefore made altogether subordinate. The free treatment of the shade side of the tower is a new point to be studied. The curling lines employed have no reason in texture, but are introduced to give variety to what otherwise would be a rather monotonous gray. The shadow of the tower upon the roof introduces a gradation which is an exaggeration of the fact, but is justified by the requirements of the composition. The generally horizontal direction of the strokes in the dark foliage of the background contrast well with the upright mass of the tower and the general vertical character of the pen work used in the rendering. A minor but important point in the treatment of cast shadows is the accentuation of their outer edges. This can be studied in all three of the drawings of this plate.

PLATE 18

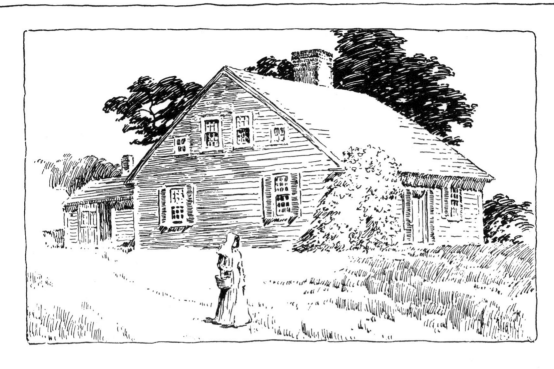

PLATE 19

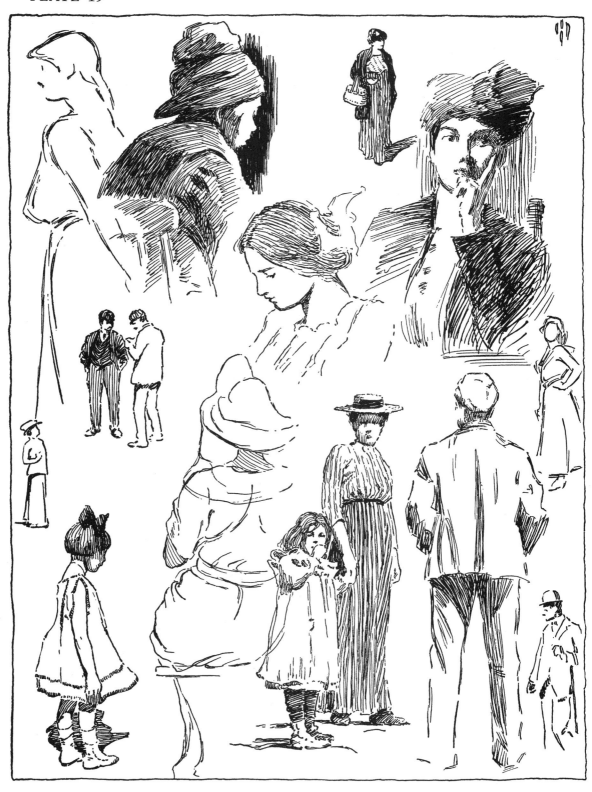

NINETEENTH PROBLEM

The sketching of figures

THE dozen sketches shown in plate 19 are intended to illustrate various methods of using the pen in figure sketching. The three largest—the old woman, the young girl looking down, and the young woman resting her face against her hand—were drawn from the pose. Some of the others, including the woman with a basket and the little girl holding the hand of an older girl, are from photographs. Several are pen renderings of sketch-book notes.

It goes without saying that one must have a good knowledge of the essentials of figure drawing in order to make an acceptable sketch of the figure in any medium; but granted the ability to make a good pencil sketch, there is still much for the student to learn before his pen will translate these essential qualities of the figure into black ink lines. The pencil or charcoal, by the grayness of which it is capable, allows of almost imperceptible gradations. A pen line may vary in width but not in value. Hence, to avoid the effect of undue harshness in face or hands, considerable experience is required. Looking at the outline action studies in the plate, we shall see that a number of fine tentative lines appear. The pen was used with almost as much freedom as the pencil, and the more important places were accented by added strokes made with more pressure. The making of many such free outlines is a good exercise for the student, to give him courage in using the pen freely. If he can learn to make such studies without preliminary pencil lines, so much the better.

The boy with his hands in his pockets, standing back toward us, illustrates a free treatment of simple shadows. The tiny sketch beside it in the lower left corner also shows how a few shadows with the needful outline touches tell the story in a drawing of small scale. Such a treatment of a figure might appropriately be used when the figure appeared as an accessory in a landscape or architectural subject. All color values are omitted in this sketch, but in the little figure of the woman with the basket at the top of the page the color values are shown clearly, while the shadows also are indicated. This is also the treatment of the group of the child and

young woman at the bottom of the page. The method of indicating the stripe of the dress is to be especially noted.

The young woman with her hand against her cheek shows full light and shade as well as the suggestions of color. Coarse and fine lines produced by varying pen pressure are employed here to good effect, for the coarser lines of hat, hair, and coat juxtaposed to the finer strokes used in the shade of hand and face accentuate the comparative delicacy of the latter and help by contrast to suggest the softer character of the flesh.

It is impossible to lay down rules to guide the student in acquiring a free, interesting, and vigorous pen technique for figure work. The best that he can do is to study excellent examples such as the drawings of Abbey, Pyle, Sterner, Frost, Rackham, and other of the master illustrators, and to practice persistently until the pen loses its unsympathetic feeling in his hands. Really excellent pen drawing of the figure is as difficult as a masterly rendering of it in any other medium. But a reasonably satisfactory method of pen work can be acquired by anyone who can draw the figure and who will persist in drawing it with the pen. A method that is obvious but craftsmanlike is not unpleasant in the various forms of decorative pen drawing which have been discussed. A semi-formal method passes acceptably in still life and architectural subjects, but in the figure flexibility and vivacity—in short all the qualities needful to suggest life and individuality—can be expressed well only with a very sympathetic and varying quality of line. The student who appreciates the ideal will make his practice of the right kind. This plate then is to suggest the types of sketches that he should make, thoughtfully but in great numbers.

TWENTIETH PROBLEM

Studies of heads

THE original drawings of plate 20 were slightly larger than they appear in the reproductions, but the pen manipulation nevertheless is clearly evident. It is unnecessary to enter into an analysis of the method after what has been said in connection with the last problem. All that will be attempted therefore is to call the attention of the student to certain things which were borne in mind in making the studies. In the first the very loose treatment of the hair should be noted, which gives it the fluffy effect characteristic of the subject and the style in which the hair is worn. Compare this treatment with that used in the old man's hair, and again with that of his moustache and of his beard. Shapes of shadows and values are important, but there is also a difference in the lines themselves. In a sense, each line is typical of the kind of hair, whether coarse and loose, fine and close, long or short, straight, curved, or wavy.

The shadow upon the girl's face is drawn with lines that follow and describe the modeling of that side of the face. Eyes and mouth, as well as the shadows beneath the nose and on the ear, are formed without outlines. But slight dependence has been put upon cross-hatching. Finally, all modeling is omitted from the light side of the face and only the slightest indication of the neck and shoulders appears. A simplicity and smoothness of modeling characteristic of youth and a concentration of interest upon the face is the result.

The old man's head is less direct in its treatment. It is worked out with more attention to details of modeling, of color, and of shadow gradations. The shadow upon the neck expresses the character of the skin and flesh, the bony structure of the skull is clearly accentuated, and the face has the thin, drawn appearance of old age. The pen has felt its way over the surfaces with care for construction and for external textures. A sprightly technique like that used in the young girl's head would have been altogether out of place in this study of old age.

The head of the young Italian girl is not treated altogether differently from the first drawing. The color contrasts, however, give it as much

difference of character as do the actual forms represented. The hair, thick and matted, is expressed in lines to convey that impression, and the pen work throughout is more brutal, or at least has far less delicacy than that of the first sketch. The subject, with its square jaws and rather coarse features, does not demand delicacy of touch.

The fourth head is interesting for its simple treatment of the shadow cast by the hat over hair and face. While many fine lines go to make up the shadow, it is kept transparent and fresh and expresses the modeling as well as the color contrasts of hair and face. The omission of shade in the hat and the use of a few strong strokes of dark upon the dress collar are both points that add interest to the drawing as a whole.

For practice in drawing heads the student would do well to translate photographs into pen drawings, taking such liberties as are necessary to concentrate the interest and to produce a pleasing result in line and value.

PLATE 20

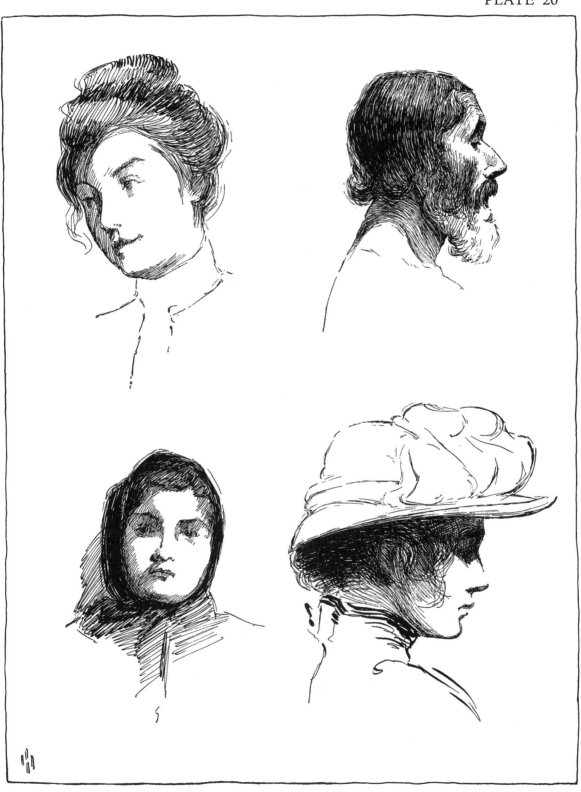

TWENTY–FIRST PROBLEM

Complete figure sketches

PLATES 21 and 22 show examples of pen sketches from the model and are of the kind that may be attempted where perhaps an hour's time may be taken for the study. After making a careful pencil sketch which should insure right action, proportion, and the correct forms of the larger shadow masses, the beginning of the pen work may well be the laying in of the dark masses of shade, the pen being used with a good deal of pressure to give the necessary width of stroke and the lines being drawn without raising the pen, so that both the upward and downward movements produce lines. This is the most direct and most rapid method of using the pen as well as the most informal. It may easily degenerate into carelessness unless the student keeps close watch of form and values, but it allows more freedom in the study of full light and shade of large masses than a more sophisticated technique.

After the shadow masses are put in the general values of the lights and half lights may be added with the same free swinging lines.

Faces (and hands also) generally require the careful treatment that has been discussed in connection with the last problem, although it is not always necessary to concentrate attention upon these parts. The entire pose may be of greater purport than even these most significant parts.

The further consideration of figure drawing would carry us beyond the scope of this book into the domain of figure composition. The student who has carried his pen drawing to the present point should be ready to experiment for himself in the more advanced problems which confront the illustrator. The serious study of the best examples of modern pen illustration will do much to help him to form a style suited to his own needs. No course of study, however good, can give him the impulse to produce things of interest, for that impulse is a personal matter. Unless one has the desire to do original work, that is, to express in graphic form subjects that he sees or that he imagines, no technical instruction can serve more than the purpose of leading him to an appreciation of the work of others. This alone, however, is a great deal to gain and in itself justifies the general study of art, or the study of a special field of art.

PLATE 21

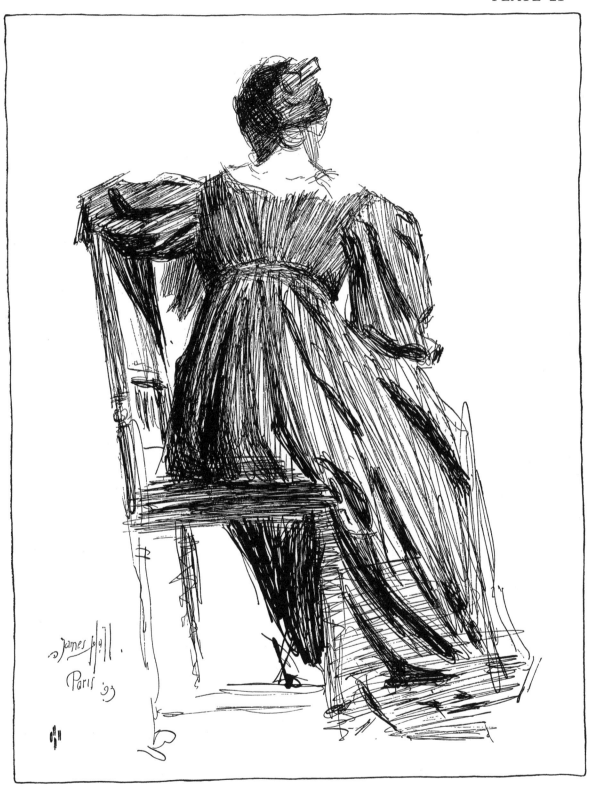

PLATE 22

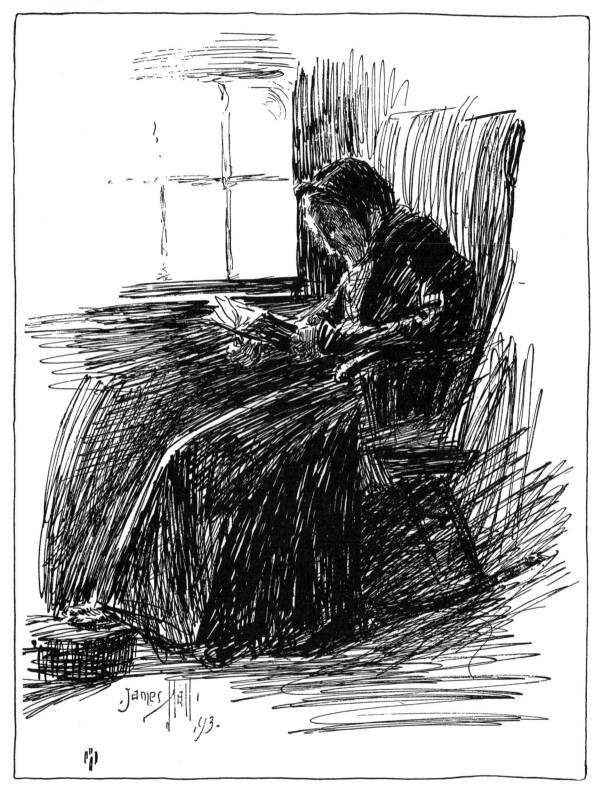

A SHORT LIST OF BOOKS

PEN DRAWING AND ILLUSTRATION

Pen Drawing and Pen Draughtsmen. JOSEPH PENNELL. Macmillan & Co. 1889*

Modern Illustration. JOSEPH PENNELL. George Bell and Sons. 1898

Pen Drawing. CHARLES D. MAGINNIS. Bates and Guild. 1900*

The Decorative Illustration of Books. WALTER CRANE. George Bell and Sons. 1901

Modern Pen Drawings: European and American. Edited by CHARLES HOLME. Offices of "The Studio." 1901

Pen, Pencil, and Chalk. A Series of Drawings by Contemporary European Artists. Edited by CHARLES HOLME. "The Studio." 1911

Modern Book-Plates and their Designers. "The Studio" Special Winter-Number. 1898–99

Children's Books and Their Illustrators. GLEASON WHITE. "The International Studio" Special Winter-Number. 1897–98

ALPHABETS AND LETTERING

Letters and Lettering. A Treatise with 200 Examples. FRANK CHOUTEAU BROWN. Bates and Guild. 1902

Writing and Illuminating and Lettering. EDWARD JOHNSTON. The Macmillan Company. 1906

Alphabets Old and New. LEWIS F. DAY. Charles Scribner's Sons. 1899**

Lettering in Ornament. LEWIS F. DAY. Charles Scribner's Sons. 1902

Alphabets. EDWARD F. STRANGE. George Bell and Sons. 1895

Manuscript and Inscription Letters. A Portfolio of Plates by Edward Johnston. For Schools and Classes and for the use of Craftsman. John Hogg. 1909

DRAWING, COMPOSITION, AND DESIGN

Freehand Perspective and Sketching. D. M. NORTON. Published by the Author. 1909*

Art Education for High Schools. The Prang Company

Composition. ARTHUR W. DOW. Doubleday, Page and Company. 1913*

Figure Drawing. RICHARD G. HATTON. Chapman and Hall.*

Figure Composition. RICHARD G. HATTON. Chapman and Hall. 1900.

The Human Figure. J. H. VANDERPOEL. The Inland Printer Company. 1908*

The Craftsman's Plant Book. RICHARD G. HATTON. Chapman and Hall. 1909

The Principles of Design. ERNEST A. BATCHELDER. The Inland Printer Company. 1904

The Principles of Design. G. WOOLLISCROFT RHEAD. Charles Scribner's Sons. 1905
Modern Practical Design. G. WOOLLISCROFT RHEAD. B. T. Batsford. 1912
Nature and Ornament. LEWIS F. DAY. Vol. I. *Nature the Raw Material of Design.*
 Vol. II. *Ornament the Finished Product of Design.* Charles Scribner's Sons. 1910
The Bases of Design. WALTER CRANE. George Bell and Sons. 1902
Line and Form. WALTER CRANE. George Bell and Sons. 1901
On Drawing and Painting. DENMAN WALDO ROSS. Houghton, Mifflin Company. 1912
A Text-Book of Design. KELLEY AND MOWLL. Houghton, Mifflin Company. 1912

BOOKS LISTED FOR THEIR ILLUSTRATIONS

The Banbury Cross Series of Nursery Rhymes, Fairy Tales, etc. Illustrations by
 R. ANNING BELL, ALICE B. WOODWARD, CHARLES ROBINSON, and H. GRANVILLE
 FELL. J. M. Dent and Company. 1894–95
A Child's Garden of Verses. ROBERT LOUIS STEVENSON. Illustrations by CHARLES
 ROBINSON. Charles Scribner's Sons. 1895.
The Endymion Series. Illustrated by Robert Anning Bell, Byam Shaw, Alfred
 Garth Jones and W. Heath Robinson. George Bell and Sons.
Prue and I. GEORGE WILLIAM CURTIS. Illustrations by ALBERT E. STERNER. Har-
 per and Brothers. 1893
Old Songs, with drawings by EDWIN A. ABBEY and ALFRED PARSONS. Harper and
 Brothers. 1889
 [Also other books illustrated by Abbey]
The Story of King Arthur and his Knights. Written and illustrated by HOWARD PYLE.
 Charles Scribner's Sons. 1903*
 [Also other books of the series]
A Midsummer-Night's Dream. SHAKESPEARE. Illustrated by ARTHUR RACKHAM.
 Doubleday, Page and Company. 1908*
Undine. DE LA MOTTE FOUQUÉ. Adapted from the German by W. L. COURTNEY.
 Illustrated by ARTHUR RACKHAM. Doubleday, Page and Company. 1909
 [Also other books illustrated by Rackham]
The Later Work of Aubrey Beardsley. John Lane. 1901

Bound volumes of the magazines, The Studio, Century, Harpers, Scribners, etc., con-
 tain examples of pen drawings from which can be gained a knowledge of the work
 of the foremost pen draughtsmen of the present generation.

* Available from Dover Publications

PLATE 23

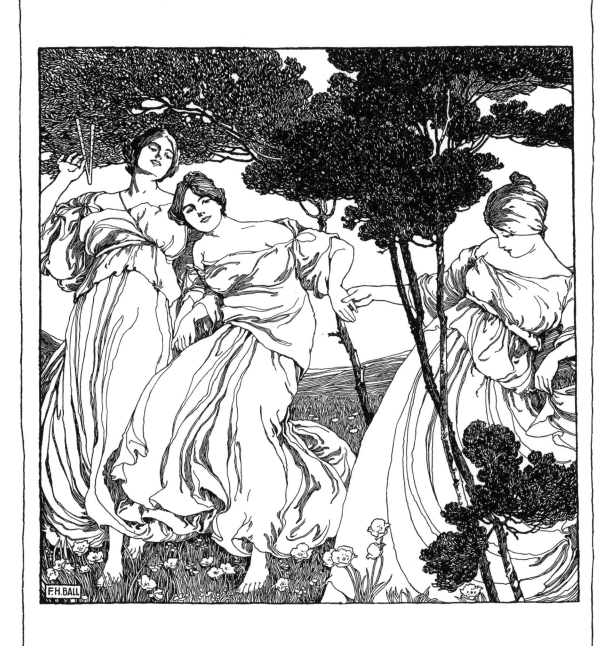

PLATE 24

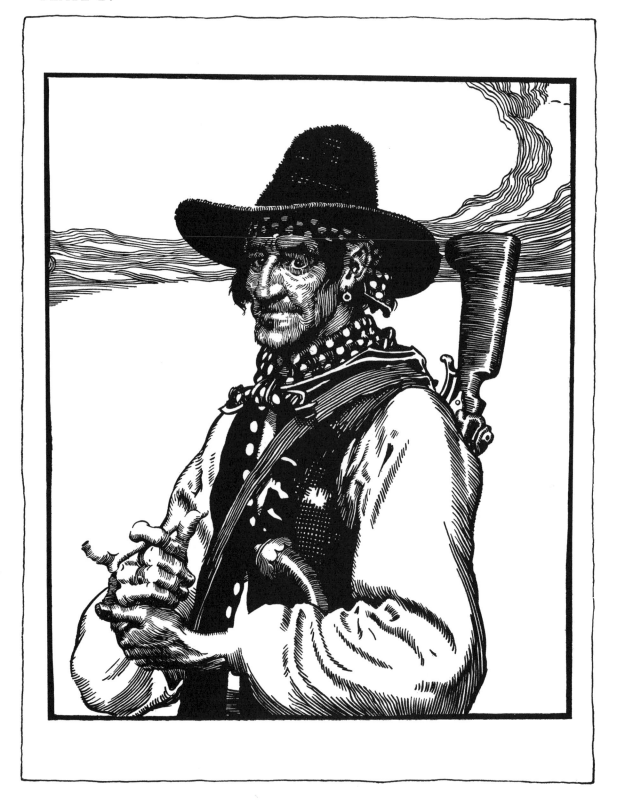

72

PLATE 25

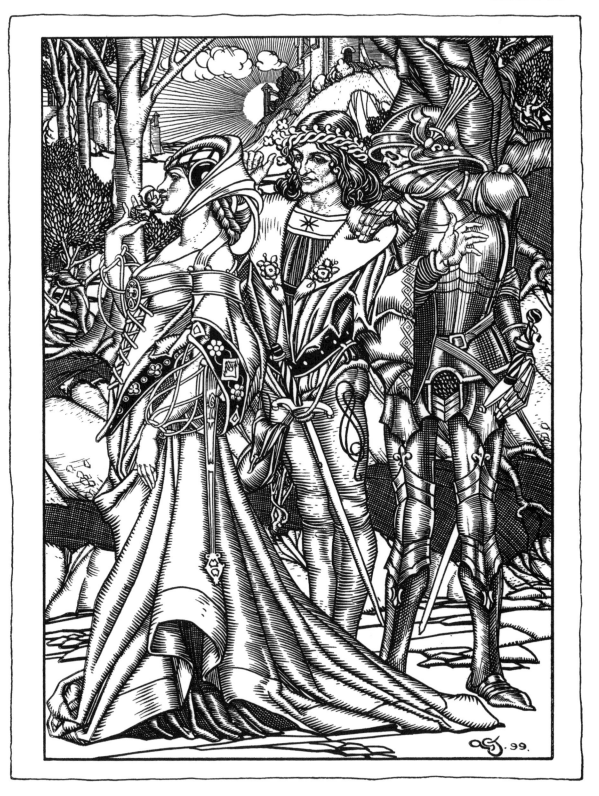

PLATE 26

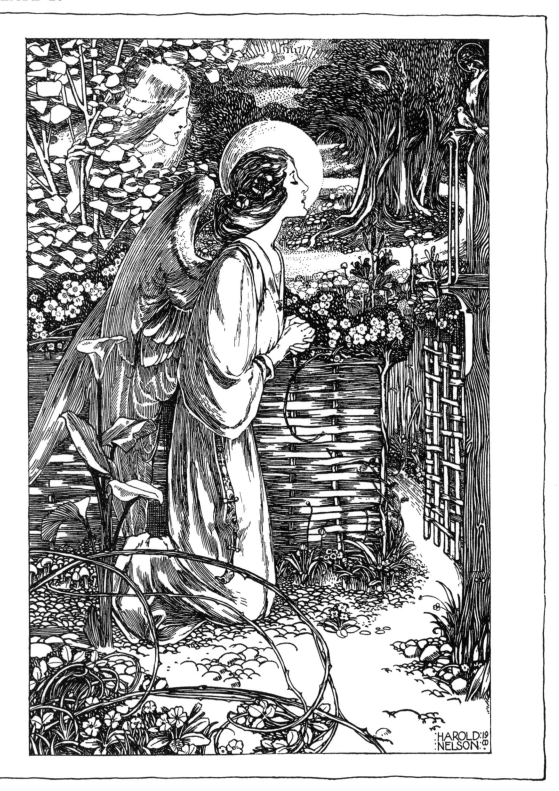

PLATE 27

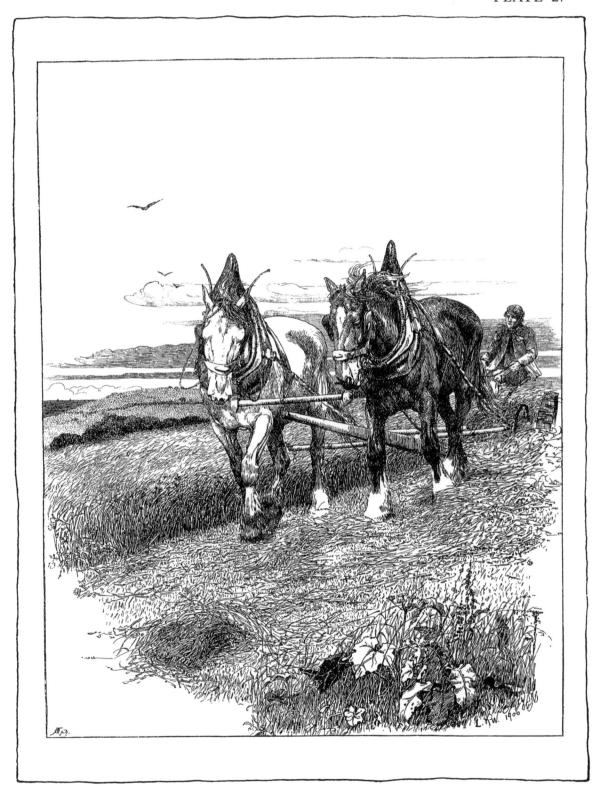

PLATE 28

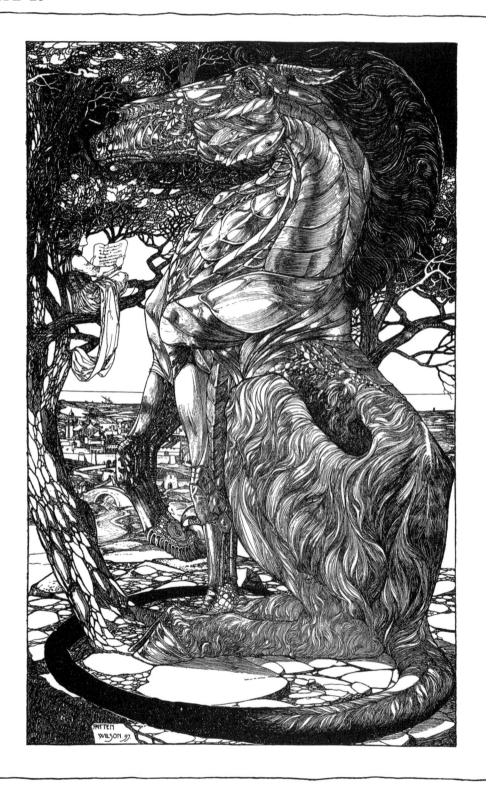

PLATE 29

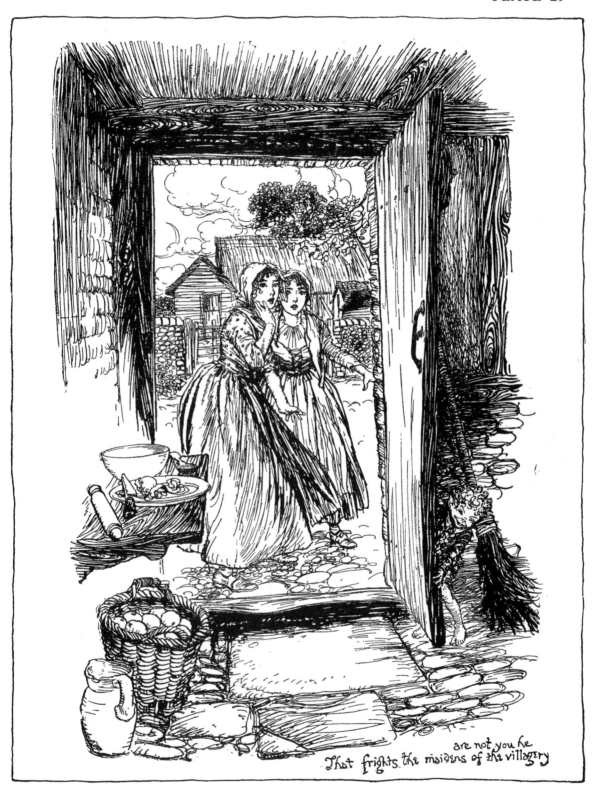

are not you he
That frights the maidens of the villagery

PLATE 30

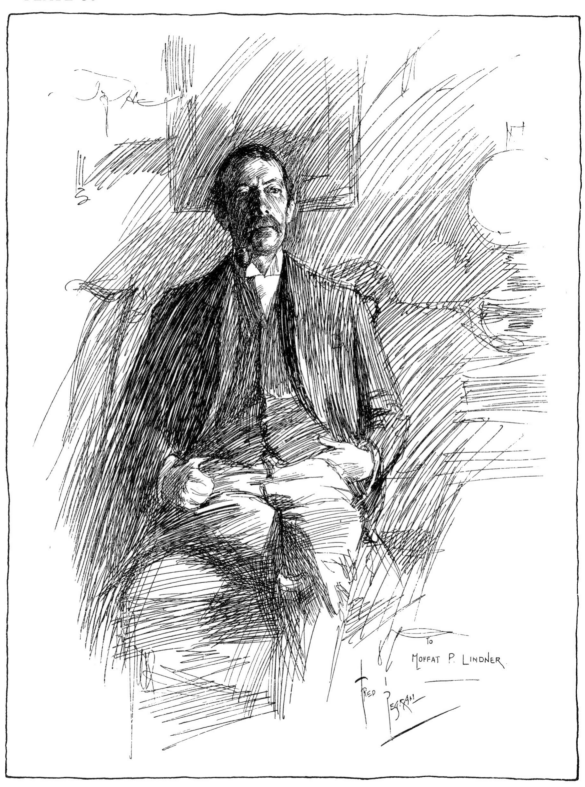

To MOFFAT P. LINDNER

PLATE 31

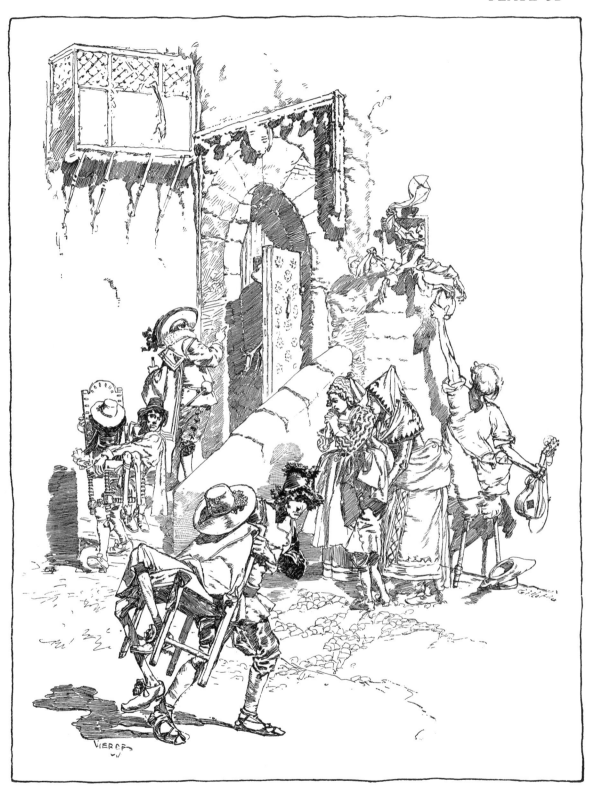

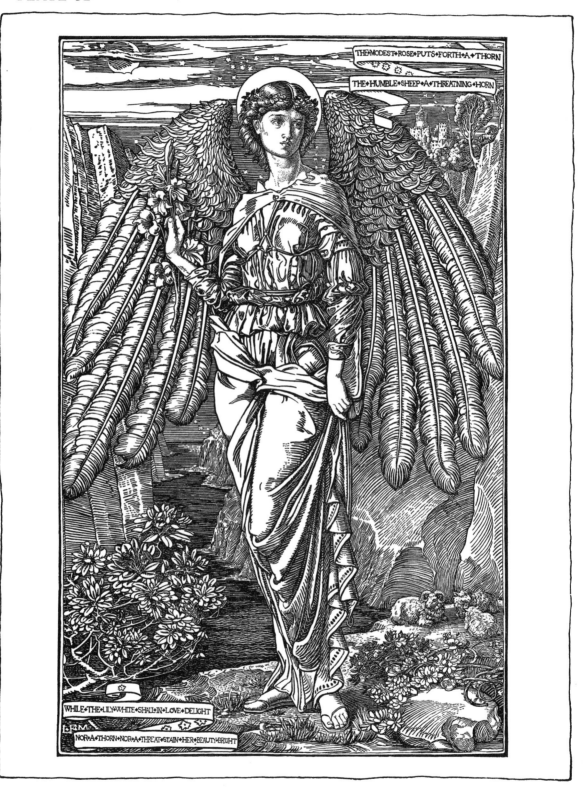

PLATE 32

THE·MODEST·ROSE·PUTS·FORTH·A·THORN

THE·HUMBLE·SHEEP·A·THREATNING·HORN

WHILE·THE·LILY·WHITE·SHALL·IN·LOVE·DELIGHT

NOR·A·THORN·NOR·A·THREAT·STAIN·HER·BEAUTY·BRIGHT